MAKE YOUR

Scanner

A GREAT DESIGN & PRODUCTION TOOL

MICHAEL J. SULLIVAN

NORTH LIGHT BOOKS

CINCINNATI, OHIO

About the Author

Michael J. Sullivan is partner and artistic director of Haywood & Sullivan in Quincy, Massachusetts, an award-winning full-range design firm that excels at communication design using various media. He is also a founding partner of Pilgrim New Media in Cambridge, Massachusetts, a multimedia titles publisher. Holding degrees in both design and computer science, he is a regular contributor to design and computer-related design publications, such as *HOW* and *Publish*.

Make Your Scanner a Great Design & Production Tool. Copyright © 1995 by Michael J. Sullivan. Printed and bound in Hong Kong. All rights reserved. No part of this book may be reproduced in any form or by any electronic or mechanical means including information storage and retrieval systems without permission in writing from the publisher, except by a reviewer, who may quote brief passages in a review. Published by North Light Books, an imprint of F&W Publications, Inc., 1507 Dana Avenue, Cincinnati, Ohio 45207. 1-800-289-0963. First edition.

99 98 97 96 95 5 4 3 2 1

Library of Congress Cataloging-in-Publication Data

Sullivan, Michael (Michael J.).
 Make your scanner a great design and production tool/ Michael Sullivan.—1st ed.
 p. cm.
 Includes index.
 ISBN 0-89134-617-1
 1. Computer graphics. 2. Scanning systems. I. Title.
T385.S82 1995
006.6—dc20 94-47121
 CIP

Edited by Poppy Evans

The permissions on page 133 constitute an extension of this copyright page.

METRIC CONVERSION CHART		
TO CONVERT	TO	MULTIPLY BY
Inches	Centimeters	2.54
Centimeters	Inches	0.4
Feet	Centimeters	30.5
Centimeters	Feet	0.03
Yards	Meters	0.9
Meters	Yards	1.1
Sq. Inches	Sq. Centimeters	6.45
Sq. Centimeters	Sq. Inches	0.16
Sq. Feet	Sq. Meters	0.09
Sq. Meters	Sq. Feet	10.8
Sq. Yards	Sq. Meters	0.8
Sq. Meters	Sq. Yards	1.2
Pounds	Kilograms	0.45
Kilograms	Pounds	2.2
Ounces	Grams	28.4
Grams	Ounces	0.04

Introduction

This book assumes you have a scanner and scanning software. It assumes you have access to some sort of image-editing software (for color correction, cropping, rotating, eliminating dust and scratches, etc.). And it assumes you know how to install the above items.

Throughout this book I refer to Adobe Photoshop and its filters and effects when I am talking about image-editing software. I do this for two reasons. First, Photoshop is the most widely used professional-quality image manipulation product on the market. Second, it is also the most widely copied. Thus, products such as Aldus PhotoStyler have all of Photoshop's commands (and then some). In addition, most software now supports Photoshop's plug-in architecture. A scanning plug-in that works in Photoshop also works with Fractal Design Painter. In short, Photoshop has become the lingua franca of the scanning world. If your software doesn't have a certain feature mentioned here, you may need to figure out a work-around. In either case, I have made an effort to only show techniques that I feel either are or should be universal in any scanner repertoire.

Credits and Acknowledgments

All photographs used in this book, with the exception of those used in the Gallery section, Coloring an Old Photo, Salvaging a Faded Original, Calibrating Your System, or where otherwise noted, are ©1994 Michael J. Sullivan, all rights reserved.

The image of Olé No Moiré is courtesy of Adobe Systems, Inc. The diagram How a Scanner Works is courtesy of Agfa Division, Miles Inc. The borders and clip art examples on pages 88 and 89, as well as the high resolution line art example on page 80, are from a turn-of-the-century type and ornaments spec book from an unknown publisher (the cover had been destroyed). The line art examples on pages 86 and 87 were scanned from *Americans* drawn by Charles Dana Gibson, printed by R.H. Russell, Publisher, New York in 1900.

Thanks are in order to my editors, Poppy Evans and Greg Albert, whose guidance (and patience) were so valuable. Mary Cropper deserves special commendation for the early editorial work and vision that got this book off the ground. Thanks also for the invaluable help and enlightenment I received from the following individuals: Bob Schlowsky, Ed Granger, Steve Hollinger, Melody Haller, Francois Gossieaux and Lavon Peck.

This book is dedicated to my patient and supportive wife, Liz, and to my daughter, Megan, who did without her dad for so many weekends.

This book was created electronically using Quark-XPress 3.2 on Apple Macintosh computers. All images were captured using either an Agfa Arcus Plus scanner or a Polaroid SprintScan 35 slide scanner. Most images scanned on the Agfa Arcus Plus were done so using Agfa's FotoLook Photoshop plug-in. Other images, where noted, were scanned using Ofoto software from Light Source Computer Images, Inc. Line conversions were produced using Adobe Streamline and saved as EPS files. Image files were separated in Photoshop using calibrated separation tables and saved in five-file EPS format with 8-bit preview.

Table of Contents

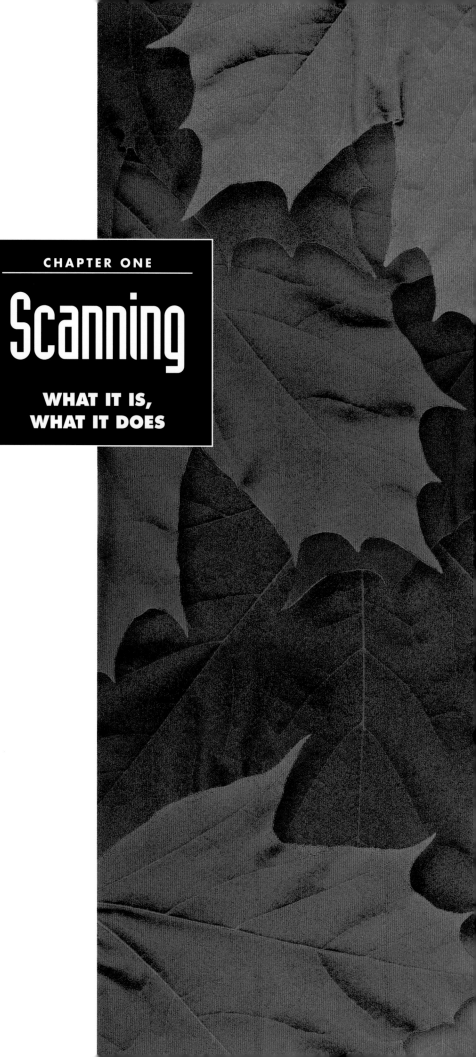

CHAPTER ONE

Scanning

WHAT IT IS, WHAT IT DOES

The Scanner as an Input Device

The scanner is simply a gadget for getting images into your computer. That's it. But as you probably know, getting good images from your scanner requires more forethought and expertise than simply scanning them into your computer.

For one thing, getting good results requires knowing how to correct images with the tools in an image-editing program. However, this book is not about image manipulation techniques, per se. (If you want to become a Photoshop wizard, please see the appendix for a list of supplementary literature.)

Plus, you'll find that not all images can be "fixed" in an image-editing program. The old saying "garbage in, garbage out" applies to scanned images. It's far better to "fix" images at scan time than to try to fix them later in Photoshop or your favorite image-editing program.

To some degree, great scanned images are also the result of good equipment. This explains why your images don't look as good as the professionally scanned images you see in magazines and brochures. It's clearly due to the high-end equipment that publishers can afford to use.

Although great chefs can usually be found in great kitchens, they can also perform their art under less-than-ideal conditions. Even though you may "only" have an entry-level flatbed scanner, you can still achieve stunning results with it.

If you want to make the most of your equipment, optimize your scanning time, and deliver the best possible images, then this book is for you! You'll find your scanner can be a really valuable tool when you know how to get good results from it.

How Scanners Work

The scanner is an electro-optical device that captures image data one line or "scan" at a time, hence the name. Using optics much like a camera's, a scanner moves over the imaging area, called the bed, which is defined by a grid of (x,y) coordinates. Each (x,y) coordinate defines a sample area and the resulting captured image is described in samples per inch (spi).

Each sample is exposed to a light source of a known intensity. The light either passes through (in the case of a transparency) or is reflected from (in the case of artwork) an original. This light then makes its way through the optics of the scanner to a sensor, which converts the light to an electrical charge. The strength of the charge is in direct proportion to the intensity of the light, which is a reflection (no pun intended) of how light or dark the original sample is. The electrical signal is then converted to a digital signal using an analog-to-digital converter. It is this digital information that makes up the data in your scan.

Since each individual scan line must be calculated separately, scanners are not used to capture moving objects—the scanner is not a camera. But you can use a scanner much as you would a camera to capture 3-D artwork.

For more information see Scanning 3-D Objects on page 64.

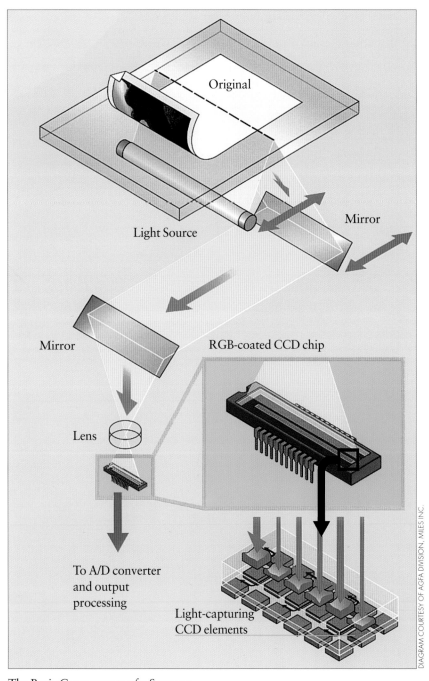

Original

Light Source

Mirror

Mirror

RGB-coated CCD chip

Lens

To A/D converter and output processing

Light-capturing CCD elements

DIAGRAM COURTESY OF AGFA DIVISION, MILES INC.

The Basic Components of a Scanner.

Scanning and Its Relationship to Output

Halftone screens came about as a way to print, in four color and in black and white, the tone gradations that appear in photographs and illustrations. Halftone screens consist of many spots in varying degrees of concentration. In black-and-white or one-color printing, the concentration of spots is 100 percent for solid black or a solid area of color. A white area, or area of no color, is represented by a spot concentration of 0 percent. The range of spot concentration in between varies from 1 percent in the lightest regions of an image to 99 percent in the darkest.

Four-color reproduction is similar in that the four process colors (cyan, magenta, yellow and black) are combined in spots of various concentrations to yield an array of colors and tones. Each color in a printed image is the result of a blend of four halftone screens—one for each of the four process colors.

In the reproduction of digital images, three factors need to be taken into consideration:

- The image's output resolution as defined by the number of dots per inch (dpi). 300 dpi is typical of laser printer output to plain paper, whereas service bureau imagesetters typically output images on photosensitive paper or film at a resolution of 1,200 or 2,400 dpi.
- Spot concentration, ranging from 0 to 100 percent as explained earlier.
- Halftone or screen frequency as measured in lines per inch (lpi). This term may

EXAMPLES OF VARIOUS KINDS OF SCREENS

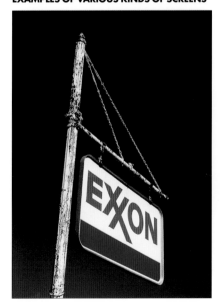

85 lpi.

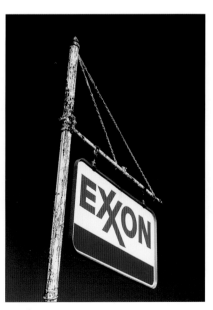

133 lpi.

150 lpi.

seem confusing because it doesn't describe lines per se, but rather the number of rows of spots that make up a halftone screen. The lower the frequency or number of rows, the coarser an image appears. Conversely, the higher the frequency, the more refined the image is.

Clearing Up the Confusion Among spi, dpi, lpi and ppi

Basic to understanding scanning and printing images is a knowledge of the terminology involved. As I researched other resources for this book, it became clear to me that no one in the industry was consistent in using terms to describe the resolution of scanned images. Many publications use the term *dpi* to describe the scan data, only to use the same term to describe the resolution of the output device—inconsistent and confusing, to say the least. Others use the term *ppi* (pixels per inch) to describe scanned data, a term that is also used to describe a computer's screen resolution.

In this book I have chosen to use the term *spi* (samples per inch) to describe the *scan data*. In essence, spi is the input frequency used when scanning the original. I also use the term to describe the frequency of the sample data when an image is scaled at output time. For example, although an image may be scanned and saved at 300 spi, when it is scaled to 50 percent of its original size in a page layout program, its effective sample frequency becomes 600 spi.

Because samples are not the same as laser printer dots, halftone spots or computer screen pixels, all other such prepress and desktop publishing terms (such as dpi, lpi and ppi) are used to describe output.

For more information see Choosing the Best Screen Frequency on page 23.

Recommended Settings for Line Art Scanning

TERM	MEANING	DESCRIPTION	TYPICAL MEASUREMENTS
SPI	Samples per Inch	Input Frequency of Scanned Image	300-600 spi (flatbed) 1850-3600 spi (slide)
DPI	Dots Per Inch	Resolution of Imagesetter (output)	300-2400 dpi
LPI	Lines Per Inch	Halftone Frequency for Printer (output)	133-40 lpi
PPI	Pixels Per Inch	Resolution of Computer Screen (output)	65-96 ppi

This chart defines the various terms and typical output frequency for each.

The Scanning Process

The following is a basic step-by-step overview of the scanning process:

Step 1: Preview

Previewing lets you see a quick, small-scale version of the image before committing to the final scan. At this stage, you also see a frame or marquee around the image. You can adjust this frame so that it crops in on the portion of your image that you wish to scan.

Step 2: Crop to Desired Size and Shape

It's important to crop an image before scanning as opposed to after in your image-editing or page layout program. Cropping at the scanning stage reduces the amount of time needed to scan. Cropping also determines the way your image will look by confining the area in which the scanner's tone controls sense the darkest and brightest areas of the image.

Step 3: Decide on Input Mode: Line Art, Halftone, Grayscale or Color

LINE ART (also called 1-bit or bitmapped) is the best mode for scanning pure black-and-white originals, such as drawings, logos, signatures, etc. Line art should be scanned at the same resolution as the final output device to obtain maximum detail.

HALFTONE (or **DITHERED**) is used for scanning black-and-white photos or color photos to output in tonal gradations from black to white. This mode is a 1-bit format that simulates shades of gray by either creating halftone spots, halftone lines or diffusion patterns. This option is typically used for final output to low-resolution black-and-white laser printers. The high-resolution imagesetters that are found at service bureaus output grayscale images as described on page 8. Halftone scans cannot be reverted to grayscale mode.

GRAYSCALE is the best mode for producing a black-and-white image with a realistic tonal range of grays. Its 8-bit continuous tone configuration produces 256 variations of gray for each sample and provides the greatest flexibility when working with black-and-white images. It's used primarily for producing black-and-white photographs and film negatives.

Scanning for Output Method

This 200-spi, 8-bit grayscale scan gives you the greatest flexibility. It can be colorized, posterized and otherwise manipulated to your heart's content. However, images scanned in grayscale mode generally result in larger files than other black-and-white modes.

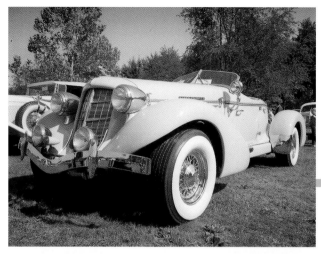

516 k

Scanning the same image as a 1-bit halftone results in a dithered pattern where small black dots represent the various shades of gray.

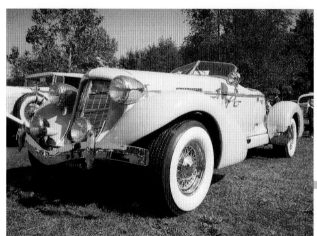

264k

Threshold scanning is useful when you want the unique look of a high-contrast image. Many designers use this effect for backgrounds and other graphic elements.

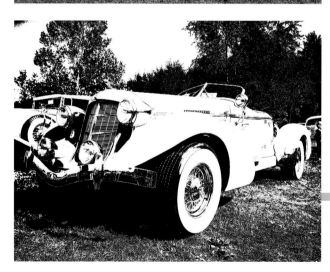

264 k

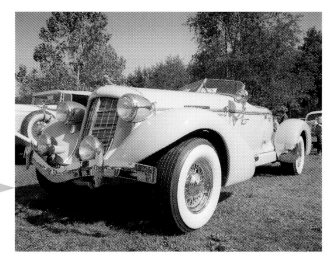

When output as a 75-lpi halftone at 600 dpi, this grayscale scan reproduces beautifully as a continuous-tone halftone.

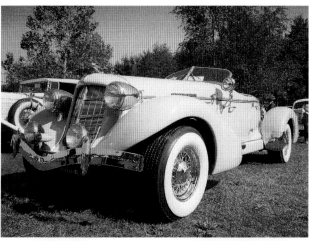

When output at 1,200 dpi this dithered image looks almost as good as the 75-lpi halftone. You may think that because it's a 1-bit image you have a smaller file, but that's not the case. Since this image required twice as many samples per inch as the corresponding grayscale image, it resulted in a file size comparable to that of the grayscale version.

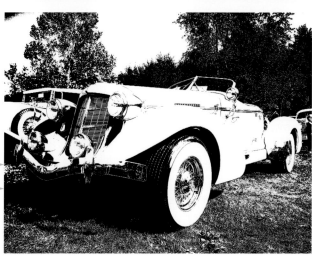

Scanned at 400 spi and output at 1,200 dpi, this 1-bit threshold image achieves a fairly high degree of detail. However, bear in mind that you can achieve the same high-contrast effect by bringing grayscale images into most page layout programs.

COLOR is the mode to select when working with a color image or when colorizing a black-and-white image. Its 24-bit continuous tone configuration produces 256 variations of each of three colors, red, green and blue (RGB), for a total of 16,777,216 possible colors per sample. (256 x 256 x 256). It's used primarily for producing color photographs and slides.

Step 4: Decide on Input Resolution (spi) and Scale

In the appendix of this book you'll find tables on pages 120-122 to help you determine the proper calculations needed for optimal spi/scale settings. However, here are some general guidelines you can follow for the various input modes.

LINE ART Output should be a multiple of the sample rate because the imaging data is sent directly to the laser printer or to the imagesetter's image engine. A 300-dpi laser printer needs line art at a resolution of 300 spi or 150 spi (a multiple of 300). For output to a 1200-dpi imagesetter, scan at 300, 600 or 1,200 spi. You are limited in scaling this image in a page layout program if the resolution of the scaled image is not a multiple of the final dpi output. But the obvious advantage of using line art mode is that it produces a much smaller file than an image scanned in grayscale or color mode.

For more information see Scanning Fine Line Art on page 86.

GRAYSCALE An spi setting of 1.5 to 2 times output frequency is usually the maximum you should scan. For example, a grayscale image that will be output to 150 lpi (regardless of the output resolution of the laser printer or imagesetter) should be scanned at 225 to 300 spi.

COLOR As for grayscale, an spi setting of 1.5 to 2 times output frequency is the maximum you should scan. Because an RGB color file is three times the size of the same version of the image scanned in grayscale mode, keep the image resolution as low as possible without compromising quality.

NOTE: For permanently archiving grayscale and color images, scanning at the highest possible resolution (300 to 600 spi or more) is advised. You can resample the image to a lower resolution in an image-editing program when the image is retrieved.

The right scanning resolution and scale for an image also depend on its ultimate destination.

HIGHEST RESOLUTION SAMPLING As mentioned before, scanning at a high resolution is important when archiving an image. You should also scan at a high resolution when outputting an image on a larger scale. For example, a 600-spi scan delivers 300 samples per inch when output at 200 percent of its original size. Conversely, a 300-spi scan delivers 600 samples per inch when output at 50 percent of its original size. Ultimately, your computer's power and speed determine how large a file you can work with. An 8" x 10" color image, scanned at 300 spi (a 2-to-1 sample rate) for 150-lpi output at 1,200 dpi results in a 21.6MB file. Not every computer can handle files this big!

OPTIMAL RESOLUTION SAMPLING This sampling gives the best possible results for your image's output destination at a resolution that doesn't result in an enormously large file. You can figure out what the optimum scan resolution should be when you know exactly what size your scanned image will be for final output. For example, a color 8" x 10" image scanned at 100 percent using a 1.5-to-1 sample rate for 133-lpi output (200 spi) results in a more manageable 9.6MB file. When printed at the same size, the quality of this 200-spi image is more than adequate for most printing applications.

FPO SAMPLING These are low-resolution images used for position only that will be replaced with a much higher resolution version of the same image at a later time. They require a minimum amount of memory, meaning they are faster to work with and easier to store than high-resolution images. A typical sample rate is 72 spi, which matches most screen resolutions. A color 8" x 10" image scanned at 72 spi results in a mere 1.2MB (24-bit color) or 414K (8-bit color) file size.

Step 5: Adjust Tone Controls

Your tone controls depend on your particular software/hardware combination. The names for the various tone controls and how they perform are not consistent from program to program. For example, some programs use the term *lightness* for gamma (midtone lightness), whereas others use gamma for overall lightness. Unfortunately, you can only determine how to adjust tone controls on your scanner by reading and understanding your user's manual or calling the manufacturer's technical help line.

Bit Depth, Scan Mode and File Size

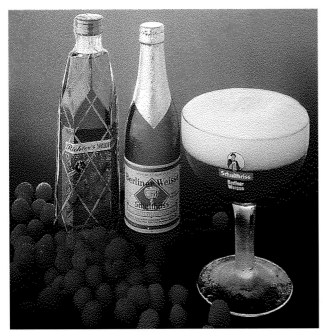

This 1-bit dithered image has a file size of 64K.

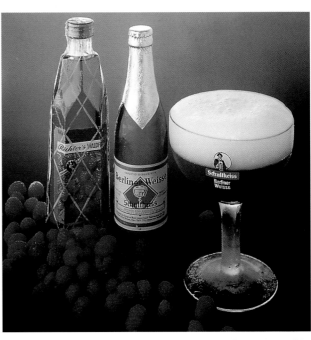

This 8-bit grayscale image, with 256 shades of gray, has a file size of 518K.

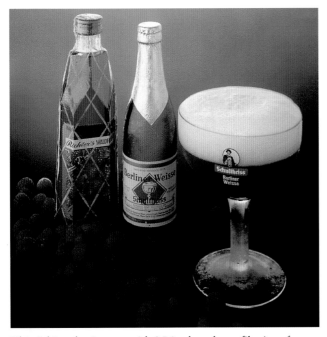

This 8-bit color image, with 256 colors, has a file size of 518K.

This 24-bit color image, with 26 million colors, has a file size of 1.55MB.

Typical setting choices include:

DMIN/DMAX These are density settings that use a logarithmic scale from 0 to 4, where 0 equals pure white and 4 equals pure black. (Most scanners limit you to about 0.1 Dmin to 3.2 Dmax.) Choose the maximum density (Dmax) and the minimum density (Dmin) for the data in your image to map to. This setting is similar to Set White Point/Set Black Point, described below, except that it allows you to set the controls numerically.

SET WHITE POINT/SET BLACK POINT This option lets you choose precisely which samples or portions of the image will map to pure white and pure black. All other colors will fall between these two extremes. A nice feature that comes with some applications allows you to remove any color cast in the white/black sample point as well.

EXPOSURE This option is especially useful when working with very dark originals where the scanner may not "see" details in shadowed areas. However, very few scanners actually support this feature. Thus, if you see this option, be suspicious—it might really be just a linearized lightness control.

LIGHTNESS You should probably avoid using this control if your scanning software offers it unless, of course, this is your scanner manufacturer's terminology for gamma or midtone brightness. Technically, *lightness* is a linearized "curve" that increases overall lightness by cropping out key data in a highlight region of the image. (I'll explain more about linear adjustments later in this chapter.)

CONTRAST You should probably avoid using this control as well. Technically, contrast is a linearized "curve" that increases midtone contrast by cropping out key data in the highlight and shadow regions of the image.

GAMMA Gamma is also known as midtone brightness. With 1.0 as the median for an image's midtones, adjusting the gamma to 1.5 lightens the midtones of an image while a gamma setting of 0.75 darkens them.

TONE CURVE Customized tone curve adjustments go beyond simple gamma controls. When you adjust the tone curve of an image you're adjusting the concentration of tone detail.

IMPORT TONE CURVE This is probably the most powerful feature for adjusting tones (if your scanner offers it). Using this option allows you to import a tone curve from an image-editing program that optimizes the way in which the scanner captures the data from an original.

HISTOGRAM This control shows a chart that depicts, on a scale of 1 to 256, the

number of instances within an image where one of 256 shades of gray appears. It is a "snapshot" of the distribution of data within your image. Thus, dark (low-key) images have most of the sample points skewed to the left, while light (high-key) images have most of the data samples skewed to the right.

Step 6: Choose Other Options

Some scanner/scanning software combinations offer Sharpening, Descreening and other controls. It is usually more efficient to take advantage of these options at scan time rather than doing them later.

NOTE: For dark originals where there is the likelihood of noise generated by the scanner, it is advisable to selectively sharpen light regions after scanning.

Step 7: Scan

The time involved in scanning depends on the size of the scan (determined by the overall resolution and bit depth), the speed of your scanner, SCSI bus and computer. Scanning used to be fairly time consuming; however, newer scanners and computers are more than twice as fast as yesterday's models. Even 20MB images may now appear on your screen in a matter of seconds.

NOTE: It won't be long before multitasking computers will be widely available. They'll enable you to do several functions, such as scan, print, save, use a modem and lay out pages, at the same time.

Step 8: Save

Do this now, before you make any changes! You may want to revert back to this original later.

Here are your options:

- Save in proprietary Photoshop native format if you want to work with the image in this program. While Photoshop native format can't be opened by desktop publishing programs, it is run-line encoded (RLE) for compact file size and it

Optimal Resolution Sizing

This 72-spi image works fine as an FPO image and has a manageable file size.

292 k

This 150-spi image scanned at a scale of 100 percent from a 5" x 7" chrome yields an image that doesn't hold as much detail as you generally want for output to print.

1.24 mb

This 225-spi scan was scanned at 100 percent. This combination of scaling and resolution produces this best image for output to print.

2.78 mb

Best

This 300-spi scan was scanned at 100 percent. This combination of scaling and resolution is best when archiving an image.

4.94 mb

offers the ability to save alpha layers, masks and clipping paths with the file.

- Save as a PICT or BMP file if you want to use the image as is for computer display. Many multimedia programs such as Macromedia Director, Apple Media Kit and HyperCard only work with PICT. BMP and PICT images can also be imported as templates for autotracing in illustration programs.
- Save in TIFF or EPS, the most popular file formats for desktop publishing. TIFF images can be imported into page layout programs. EPS files are used when a clipping path and/or CMYK separations are used.

Personally, I prefer to save the original scan in Photoshop format; that way, I know it's the "original." Only after I have scaled the image to its final size and made other adjustments for maximum printability, do I save the image, using a different name, as a TIFF, EPS or PICT file as appropriate.

Step 9: Clean Up Image in an Image-Editing Program

At this stage you should remove dust, eliminate scratches, selectively brighten and/or darken, remove noise, resize, crop further, color correct, soften, sharpen, etc.

NOTE: This work is time consuming but *very valuable*. You should work at the highest resolution your equipment can handle. Resample your image down to a more convenient size later.

Step 10: Save Again

Save this image with a different name so, if necessary, you can go back to the original scan at a later date. Of course the downside of saving two images is that you have two versions taking up valuable storage space on your hard disk.

Understanding Tone Curves and Histograms

I know it may seem intimidating, but you need to understand tone curves to produce anything beyond mediocre scans. Even professionals get confused by the complex interfaces found in powerful scanning and image manipulation programs. But don't fret. It's really rather simple.

All image manipulation and scanning tools have one thing in common: They all depict, and thus provide an interface to, the mapping of an input sample to a corresponding output sample. The classic method is a tone curve as shown in Figure 1.

An alternative (and complementary) tonal correction method is the histogram. Histograms depict the distribution of tones within an image. The legend depicts the relationship between each input tone and its corresponding output tone.

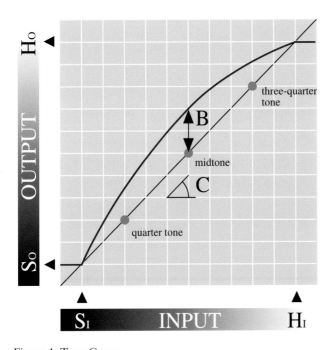

Figure 1: Tone Curve.

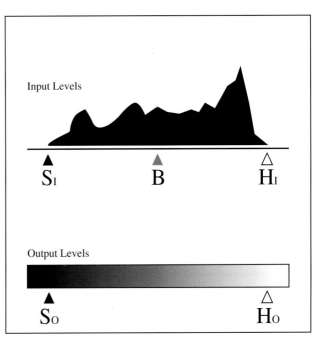

Figure 2: Histogram.

KEY
S_i = Shadow dot (input)
H_i = Highlight dot (input)
B = Midtone brightness
C = Contrast (angle of curve)
S_o = Shadow dot (output)
H_o = Highlight dot (output)

The key thing to remember is that tone curves and histograms do the same thing—map input tones to output tones. The difference is that histograms give you visual feedback, providing information on tone distribution within the image. Unfortunately, histogram adjustment is rare in scanning software—most programs just offer tone controls.

Tone Curves Made Easy

In theory, input should match output one-to-one. But that's theory. In reality, most desktop scanners can't reproduce shadow detail correctly—they simply don't have enough "vision" to see into the darker portions of an image. Thus, most desktop scans lack shadow detail and are generally too dark.

Mastering nonlinear tonal corrections, also known as gamma correction, is really a matter of bringing out the detail in the dark areas of an image and adjusting the tone range to compensate for darkness.

The key to bringing out the detail in the dark portions of an image is in increasing the contrast in that area. The more contrast you have in any given area of an image, the more differentiation there is between shades of gray—resulting in the perception of both more detail and emphasis in that area.

The degree of steepness in a tone curve corresponds to the degree of contrast. But there's a catch—you can't have a steep curve everywhere in an image! Every steep or high contrast area needs to be offset by a shallow or flat area. This is a zero sum game, people.

Likewise, you don't always get the best results if you adjust the tone curve setting on your scanner to a perfectly straight 45° angle, which represents an exact one-to-one mapping. Almost all images need some "help." Some images have important detail in the shadow areas, some have important detail in the highlight region, and some have midtone emphasis. Some images are too contrasty, some too flat, some too light, some too dark.

Using Tone Controls

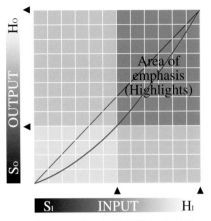

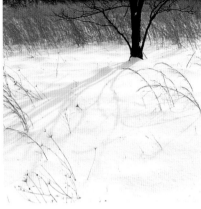

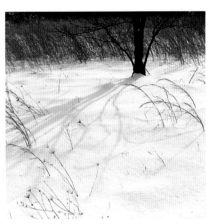

TONE CONTROL FOR SHADOW EMPHASIS **BEFORE TONE CONTROL** **AFTER TONE CONTROL**

For high-key originals (mostly lights) you want more contrast in the highlight area. The gamma equals 0.75.

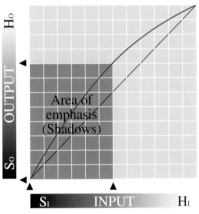

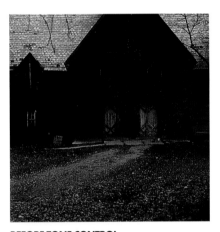

TONE CONTROL FOR HIGHLIGHT EMPHASIS **BEFORE TONE CONTROL** **AFTER TONE CONTROL**

For low-key originals (mostly darks) you want more contrast in the shadow area. The gamma equals 1.5.

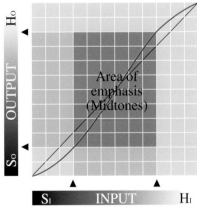

TONE CONTROL FOR MIDTONE EMPHASIS **BEFORE TONE CONTROL** **AFTER TONE CONTROL**

For some images you want slightly more contrast in the midtones. This is also known as a classic S-curve.

There are two reasons why it's far better to achieve an optimal tone curve at scan time than to manipulate the image later: First, it takes less time to scan an image correctly than to scan it poorly and adjust or manipulate it later. Second, every time you manipulate an image, you lose some data, even if just a bit. The cumulative effect of too many post-scan image manipulations is an image with less data.

To achieve the best results, keep the contrast angle steep for the most important areas of the image. There is no one formula that works best for all images. Your understanding of this fact already makes you a much better scanner operator!

Linear Corrections—A Major Post-Scanning Mistake

Fortunately, most scanning applications don't provide brightness and contrast controls, both of which are examples of linear correction. A linear correction, as the name implies, adjusts the default tone "curve" (a straight line) up and down or changes the angle of the line. In the post-scanning environment, using linear corrections is a no-no—you lose important data. More specifically, adjusting brightness shifts the tone line straight up. Data is lost in the highlights and simply disappears.

Contrast adjustments perform in a similar, linear manner. Although detail in the midtone grays is improved, the original input shadow detail is mapped to pure black, resulting in permanent data loss.

See pages 20-21 for an illustration of linear corrections.

Film vs. Paper Output

Paper output halftones are typically limited to about 110 lpi. This is because paper originals must be photographed by the printer in order to make film negatives and then plates for the printing press. When photographing the original, some detail is lost, particularly the small dots in the lighter regions of the image.

Outputting to film eliminates a step because film negatives are used to make the plates. Consequently, very small dots can be used. In general, you should output to film negatives (or film positives for processes such as silk screen) whenever possible. They give the best results.

Dot Gain — or Spot Variation

Scanning for a computer monitor is easy. A 24-bit monitor can faithfully reproduce every sample in your scanned image. However, if your image looks just right on your computer monitor, it will probably print too dark on press. This is due, in part, to the inability of the four process inks (cyan, magenta, yellow and black) to exactly reproduce every color in the spectrum. It's also due to the fact that ink spreads beyond the perimeter of the halftone spot when it is applied to paper, a phenomenon known as dot gain.

The amount of this spread is affected by the absorbency of the paper and the surface area of each individual spot. The porous surface of uncoated paper absorbs much more ink than the smooth surface of a coated paper, causing the ink to spread more, although even the shiniest of coated papers exhibits some dot gain. On an uncoated sheet, the darkest gray or shade of any color you can use without losing detail varies from an 88 percent to 95 percent tint.

Spots with greater surface area tend to exhibit more dot gain. This is especially true in areas with adjacent square halftone spots—ink tends to bridge the gap between spots, creating even greater dot gain. For this reason midtone spots generally spread more than either highlight or shadow spots.

An altogether different problem occurs when printing the lightest tints in an image. You see, a 5 percent spot at 150 lpi is *extremely* small. On press, anything smaller than this will probably not print. The combination of factors involved in offset lithography—water, blankets and offsetting—make it hard for very small dots to hold ink.

The net effect is that an image that looks "right" on your computer monitor (unless your monitor is specially calibrated for offset printing) does not print well on press. Usually, it exhibits loss of detail in shadow regions, highlight regions drop out and midtones are "muddy"—yuck!!

FACTORS AFFECTING SPOT GAIN

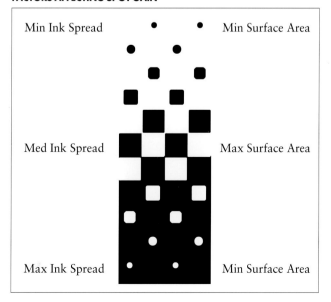

Min Ink Spread — Min Surface Area

Med Ink Spread — Max Surface Area

Max Ink Spread — Min Surface Area

What Not to Do: Making Linear Adjustments

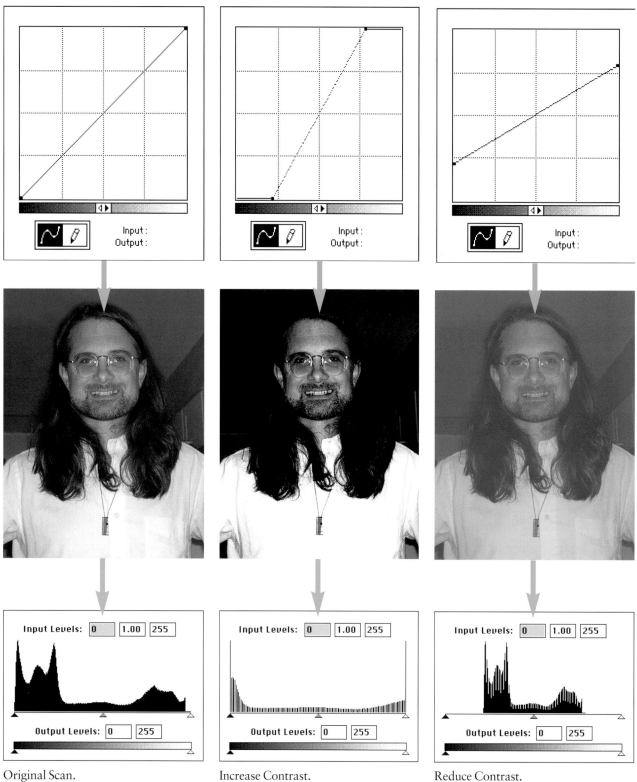

Original Scan.

Increase Contrast.

Reduce Contrast.

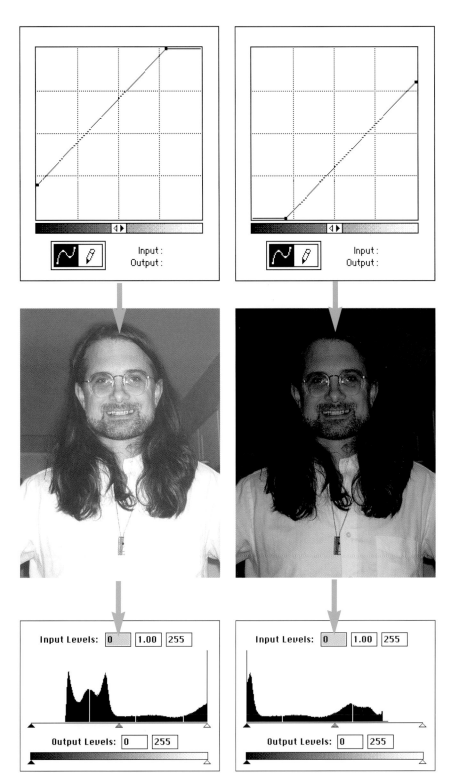

Input :
Output :

Input :
Output :

Input Levels: [0] [1.00] [255]

Input Levels: [0] [1.00] [255]

Output Levels: [0] [255]

Output Levels: [0] [255]

Lighten.

Darken.

Thus, for printing you should prepare an image so that its maximum and minimum spots are as depicted in the Screen Guidelines for Optimum Halftone Output chart. You may also want to set gamma (or midtone lightness) an additional 1.2 to lighten the midtone dot for most presses.

Screen Guidelines for Optimum Halftone Output

PAPER	MINIMUM TINT	MAXIMUM TINT	MIN OUTPUT LEVEL (on a scale of 0-256 in Photoshop's levels dialog)	MAX OUTPUT LEVEL
Coated	5%	95%	12	243
Uncoated	10%	90%	25	230
Newsprint	12%	88%	30	225

You can specify these tints when you scan if your scanning software supports it. Or you can adjust these settings in an image-editing program such as Photoshop after you scan by using the Levels command. Simply open the Levels dialog box (Command-L in Photoshop), type in the appropriate numbers for shadow output (S_O), highlight output (H_O) and midtone lightness (B) (consult Screen Guidelines for Optimum Halftone Output). Click OK and save as a new file name. The image on your screen may look somewhat washed out, but rest assured, it will give you optimum results on press.

I prefer to scan at full tonal range, since much of my scanning work is also used for multimedia purposes. Then, when I go to print, I modify the image file as appropriate for the intended output/paper combination and dot gain. I then save the modified image with a new file name. This way I have two versions of the image: the "screen" or master version that looks just the way I want it to look and the "print" version.

NOTE: Some color separation software is now able to perform dot gain on the fly at imagesetting time—check with your service bureau to see if they can provide this service for you.

How Paper Affects an Image

As mentioned earlier, the quality of an image is affected by the type of paper on which it is printed. Your paper choice dictates the maximum printing screen frequency (lpi) you can achieve, and the lpi you select affects the spi setting to use for your image file.

In general, use an spi setting from 1.5 to 2 times the printing screen frequency (lpi). Low-resolution scans should be used for 300-dpi laser output where more data won't improve the resolution of an image. On the other hand, high-resolution offset printing on coated stock demands a scan at a much higher spi setting, resulting in a correspondingly larger file.

For more information on additional sources explaining dot gain, prepress issues and printing standards see page 113 in the appendix

The Best Screen Frequencies by Output

PRINTING METHOD	PAPER USED	SCREEN FREQUENCY (LPI)	SCAN @ 1.5 TO 1 SPI
Xerographic copier	Laser paper	50-75	75-125
Quick print (paper plates)	Uncoated	50-75	75-125
	Coated	75-110	125-175
Offset Lithography	Uncoated	85-133	125-200
	Coated	120-175	180-300

File Size and Storage

Needless to say, scanning images takes lots of hard disk space. And unless you have terabytes of free space, sooner or later you have to deal with where to put all this neat stuff.

I prefer to scan at the highest resolution first, manipulate the image to remove dust and scratches, do some minor color correcting, and archive the (large) file to magneto-optical or DAT backup. I then make an optimally sized image for my intended use by resizing down. At this time I apply sharpening and any other image manipulation as necessary. All this takes place on a (mostly) clean 1.2GB fast hard disk.

Nevertheless, I often find myself swamped with hundreds of megabytes of images in no time flat. For this reason I prefer 1.3GB magneto-optical (MO) drives. I have one disk for each of my clients and their respective projects. Occasionally, I need one MO drive for just one project! Even then, I make DAT backups of the whole enchilada, in case I lose or damage my MO drives.

It goes without saying that you also need a large hard disk to work on your active projects. Photoshop not only works best with a lot of RAM but also needs a lot of free hard-disk space. Therefore, it's important to keep your main hard disk clean most of the time. Backing up your files on a daily basis (weekly at the very least) is of utmost importance.

I have outlined a few of the more popular large storage media available. Unfortunately, prices change monthly. Use this chart as a rough comparison only. But remember, you should choose media that will be compatible with others as well. Call your service bureaus or other vendors and ask them what they use. Most people will gladly give you their opinion (just take it with a grain of salt!).

Storage Media: Find the Best Option for Your Needs

TYPE	SIZE	DRIVE COST	MEDIA COST	ACCESS TIME	THROUGHPUT
Syquest	44mb	$200	$60/disk	30ms	1mb/sec
Remarks: Popular with service bureaus Low cost for drives, high cost per megabyte for media					
Syquest	88mb	$300	$80/disk	30ms	1mb/sec
Remarks: Compatible with Syquest 44 Low cost for drives, high cost per megabyte for media					
Syquest	105mb	$800	$100	15ms	17mb/sec
Remarks: Compatible with 3½" media Not quite as universal of other Syquest types Low cost for drives, high cost per megabyte for media					
Syquest	200mb	$800	$100/disk	30ms	1mb/sec
Remarks: Compatible w/ Syquest 44 and 88 Low cost for drives, high cost per megabyte for media					
Hard disks	1.2gb +	$900	NA	10ms	3mb/sec
Remarks: Needs backup to be safe SCSI 2 drives can be twice as fast as listed here					
Magneto Optical	128mb	$900	$80	40ms	700kb/sec
Remarks: Slow writes, fast reads Compact 3½" media High cost for drives, low cost per megabyte for media					
Magneto Optical	1.3gb	$2,000	$120	30ms	1mb/sec
Remarks: Slow writes, fast reads These drives are really two separate 650mb disks back-to-back					
CD recordable	650mb	$4,000	$20	200ms	300kb/sec
Remarks: Very slow writes and throughput High cost for drives, low cost per megabyte for media					
DAT	1-2gb	$700	$20	varies (depends where file is on tape)	
Remarks: Requires backup software to access files Lowest cost per megabyte for media					
DAT	4-8gb	$1,000	$20	varies (depends where file is on tape)	
Remarks: Requires backup software to access files Lowest cost per megabyte for media					

CHAPTER TWO

Types of Scans and Scanners

How to Buy a Scanner

Buying a scanner may seem simple enough. A scanner is a scanner, you might think. But buying the right scanner is a bit like buying a car—you don't want to get stuck with something you'll regret later.

There are a wide variety of scanner types to choose from with a broad range of capabilities and uses. Although flatbed scanners are by far the most popular type, other types of scanners have their places and should not be dismissed. Depending on the type of work you do, two (or more) different types of scanners may be appropriate. In my own design office, we use a flatbed, a slide scanner, a video digitizer, a digitizing tablet and Photo CD—frequently using all of them on the same project.

How Fast a Scanner?

One thing to consider when scanning an image is how long it takes to scan a file that needs color correcting. I'm not talking about the raw speed of getting a single image into your computer, but rather the overall time it takes to correct/adjust an image and then scan. Speedy scanners with old-fashioned software are as inefficient as slow scanners with more up-to-date scanning software. Unfortunately, many manufacturers are doing just that—taking old scanner designs and selling them with new, improved software. Conversely, other manufacturers are shipping newer scanner mechanisms with old-style software. Neither is optimal.

The ideal scanning setup provides fast, noise-free scans and allows you to interactively change tone, contrast and color controls during the preview mode. Once you see what you're looking for in preview mode, you should be able to simply select, scan and presto—the image you want (with no further need for color correcting) is in your computer. Scanning software that forces you to scan once, correct in Photoshop, then rescan is old-fashioned and, ultimately, less productive.

Consider the Individual Components

Scanners are complex systems that differ markedly in the quality they produce. Like a cheap stereo, a low-end scanner is OK for "background" music but not necessarily for achieving high fidelity. In general, you get what you pay for.

Likewise, the quality of each component affects the final result—after all, a chain is only as strong as its weakest link. The table on page 28 lists the various features

Component Rater

SCANNER FEATURE OR COMPONENT	BEST FLATBED SCANNERS	ENTRY-LEVEL FLATBED SCANNERS
Lightsource	Cold-cathode	Fluorescent
Optics	Color-corrected coated prisms	Plastic
# of Sensors	Multiple CCD array	Single CCD array
Sensor resolution	5000-6000	3000-4000
Sample density per scan line	600 spi	300-400 spi
Sample density per step	1200 spi	600-800 spi
Bit per sample	10 - 12 bit	8-bit
Dynamic range	3.0 - 3.2	2.2 - 2.9
Analog-to-digital converter	High-end, electrically isolated	Low-end, integrated
Box design	Sealed case	Open case

When shopping for a scanner, use this chart to evaluate each component.

common to all flatbed scanners and lists which options provide the best quality.

Wanting It All: High Resolution and Dynamic Range

When evaluating a flatbed scanner, two of the most important features to consider are its resolution and its dynamic range. Ideally, you want both high resolution and high dynamic range. In practice, it is hard to achieve. Here's why.

Most desktop scanners, including transparency and flatbed, use linear CCD (charged coupled device) array technology. Linear CCD arrays are similar to the CCD panels used in video cameras except they are arranged in a single array rather than a matrix so they can capture an individual line or "scan" of data at a time.

The vast majority of scanners on the market use a linear array of 2,000, 3,000, 4,000 or even 6,000 CCDs. By using CCDs, desktop scanners can be small and inexpensive to produce. However, CCD technology is limited in the degree of resolution it can achieve. For example, a scanner using a 5,000-array CCD scanning an 8.3" original can produce, at most, a 600-spi scan. Scanner manufacturers make up for this limitation by "stepping" the CCD array at a much higher frequency, for example, 1,200 spi. Each square inch of data is made up of, at most, 600 x 1,200 samples. Most scanning software interpolates this data to achieve an effective resolution of 1,200 x 1,200 samples, but this is not the same as a true (optical) 1,200-x-1,200-spi scan.

Dynamic range is the total amount of optical density deliverable by a scanner. In

effect, it describes the darkest shadow you can achieve. Similar to the Richter scale used to measure earthquakes, dynamic range is measured using a logarithmic scale on which 0 equals pure white (also known as Dmin) and 4.0 equals pure black (also known as Dmax). The higher your dynamic range the better, because each increase in numerical value represents ten times more potential data. A scanner that delivers a dynamic range of 3.2 is ten times "better" than one that delivers a dynamic range of 2.2!

Unfortunately, the ability of an individual CCD to capture the dynamic range of an image sample is directly related to its size. In general, the larger the CCD, the better its dynamic range. But for a flatbed, where the number of CCD elements in an array determines the final number of samples per inch, the larger the size of the CCD elements, the smaller the available resolution. Alternatively, if you increase the number of CCDs in the array, the dynamic range suffers because the size of the CCD itself, by necessity, gets smaller. It's a catch-22!

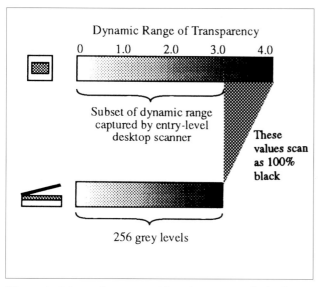

Theoretical dynamic range and how it maps to a flatbed scanner.

Most entry-level flatbed scanners have a dynamic range from 2.2 to 2.9. Midlevel flatbed scanners deliver a dynamic range from 3.0 to 3.2. High-level drum scanners can achieve a dynamic range all the way up to 4.0 (they use different technology). While a dynamic range of 4.0 may be desirable, achieving it may be moot—nothing you can scan actually has a 4.0 dynamic range. Typical reflected art maxes out at a dynamic range of 2.3, while the most a properly exposed and developed 4" x 5" transparency can hope to achieve is 3.2 dynamic range. Thus, a scanner with a *noise-free* dynamic range of 3.0 to 3.2 is all you will ever need.

Find a Scanner With a Minimum of Noise

Noise is something all CCD-equipped scanners exhibit to some degree—some more than others. Noise is random, multicolored sample points introduced into a scan as the result of the CCD array's inability to "see" the entire gamut of the original. It's basically "junk" data. You notice it most in the shadow regions of an image. This is because scanner manufacturers know that the human eye is more sensitive to light than shadow. When you're limited to a 3.0 dynamic range and the original being scanned has a

dynamic range of 3.2, something has to give. Engineers have chosen to let the shadow data go first—they figure you won't mind, and in most cases you won't. But there are many dark originals out there, and noisy scanners won't do them justice.

Noise is also created by the electronic mechanisms that run the scanner. Low-end analog-to-digital converters, common to most entry-level scanners, may introduce noise into the data stream much like a low-fidelity stereo that adds hiss and distortion to the playback of fine music. Midlevel scanners now isolate the analog-to-digital electronics from the scanner electronics to keep artificially introduced noise to a minimum. The lessons learned from the audio industry are now being adopted by the scanning industry.

Take a Test Drive

When purchasing a scanner, the biggest factor to take into consideration is how much noise it generates. To test for noise, insist on "test-driving" a scanner before you buy it. Take an image with you that has a good range of shadows, midtones and highlights (in short, your average image). Scan it, bring it into Photoshop, then apply the Equalize command (Control/Command/E). If the scanner is of reasonable quality, you won't see any streaks, splotches or bizarre noise in the image (see examples on page 32).

On the other hand, if the scanner is of questionable quality, the Equalize command will bring out and amplify the problems in the scan. You should see the look on salespeople's faces when they try to sell me a scanner at a trade show and I pull the "Equalize trick" on them. I've uncovered expensive scanners that are full of flaws using this technique. Likewise, I've found some reasonably priced scanners that provide excellent quality.

Proper Setup

Installing a scanner is usually quite easy. For the most part it's plug and play. That is, you plug your scanner into your computer, install the scanner software and play! But there can be a few "gotchas" along the way.

Some scanners have proprietary interface cards—these should be avoided, if possible, unless you A) are getting an incredible deal, B) prefer that particular kind of interface, or C) get masochistic pleasure from fiddling with your computer and resolving any incompatibilities that may ensue.

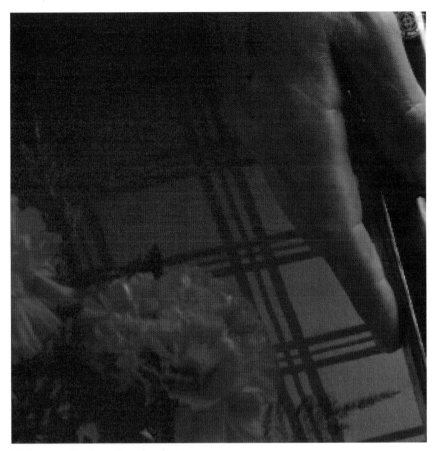

Noisy scan from an entry-level scanner.

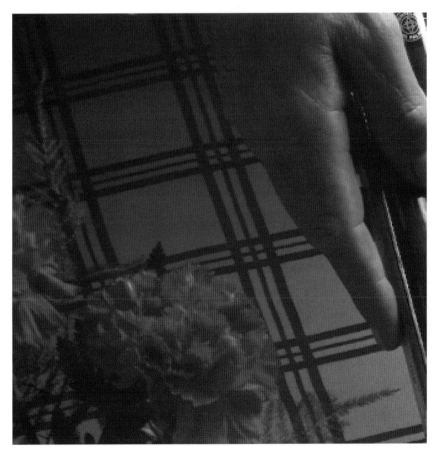

Noise-free scan
from a midlevel
scanner.

Normal scan.

RIGHT
The same scan after equalization shows heavy banding in the shadows. This scanner has serious problems.

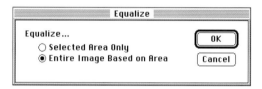

A better alternative is to choose a scanner with a SCSI interface. The big advantage to SCSI is that you can easily add on a variety of devices, everything from CD-ROM drives to removable hard disks, tape drives, modems and, of course, other scanners.

Most scanners are now available in SCSI versions—and for good reason: SCSI is an open, fast and generally reliable technology. However, many scanner communication problems are caused by borderline SCSI subsystems. You may have a borderline SCSI system if you have experienced any of the following: scans that fail to finish, slow performance, "can't find scanner" warnings, or mysterious program crashes and errors. Even hard disk crashes can be traced to failures or conflicts somewhere in the SCSI chain. Some people never have SCSI problems and can't understand what all the fuss is about. Others curse their computers daily and wonder what they did wrong in a previous life.

For PC users a SCSI driver needs to be loaded into your CONFIG.SYS file. Typically, this file is tagged with a name such as ASPI.SYS, which stands for Advanced

SCSI Programming Interface. Mac users have it easy—SCSI has been a Mac standard since the Mac Plus.

SCSI Gremlins

Unfortunately, even for Mac users, SCSI can be a black art. Master SCSI and you can legitimately call yourself a master of the universe (if you can't master it, don't fret—almost everybody else is in SCSI purgatory as well). But there is salvation. Over the years the tao of SCSI has been revealed to me. Hence, I hereby divulge The Ten SCSI Commandments:

I. Thou shalt not use cheap SCSI cables.

II. Thou shalt not use total SCSI cable length greater than eighteen feet.

III. Thou shalt keep thy SCSI IDs separate.

IV. Thou shalt use up-to-date hard disk (and CD-ROM) drivers.

V. Thou shalt consider buying active SCSI termination (such as SCSI Sentry from APS Technologies).

VI. Thou shalt always use only one terminator at the end of the SCSI chain.

VII. Thou shalt use similar quality and length cables for all thy SCSI devices.

VIII. Thou shalt patiently wait the coming of new technologies.

IX. Thou shalt suspect older SCSI hard drives as potential sources of evil.

X. Thou shalt not attempt to install more than six SCSI devices in one SCSI chain.

Follow the above commandments and you will surely avoid SCSI hell. Disregard them at your peril. Look forward to the coming of FireWire technology from Apple as well as the competing SCSI-3 specification that, eventually, will replace today's SCSI standard entirely. Until then, keep praying.

Taking Care of Your Equipment

Most desktop scanners will provide years of trouble-free service—with the possible exception of the light bulb burning out. Newer designs use cold-cathode tubes that can have lifetimes of 25,000+ hours and, thus, "never" need replacing.

As for most electrical equipment, it is also wise to provide a voltage spike protector. Other than that, the only other thing you need to do for your scanner is clean it, and cleanliness is, indeed, next to godliness. The last thing you want to do after obtaining a

Basic tools: A can of compressed air, glass cleaner, lens brush, black paper, spare scanner bulb, screw drivers, and black paper masks for 2¼" and 4"x 5" transparencies and negatives.

quality scan is to manually eliminate unnecessary dust and "grunge" spots.

Placing unusual items on your scanner may be creative, but it also puts your scanner at risk. When scanning "unusual" stuff, keep these points in mind:

- Always clean the glass platen after scanning anything that may have left residue or debris (tape, food, leaves).

- Never put anything with a sharp edge (diamonds, machined objects, hara-kiri swords) on the glass platen—it might make a permanent scratch. Instead, first put down a clear sheet of plastic film; if that gets scratched it won't matter. It's better to be safe than sorry!

- If you work with liquids, don't let any moisture get inside your unit—unless, of course, you actually like buying new equipment.

- Take care with heavy objects! Your scanner would surely object to a sumo wrestler sitting atop it. Be just as careful with heavy books and slabs of marble, too.

- Don't force the cover shut—it may just decide to snap. Instead, cover a bulky object with a white sheet. Some scanning software, particularly Ofoto, needs a white background behind a scanned object. On the other hand, you may not need anything at all—give it a try.

Types of Scanners

Flatbed

The most popular type of desktop scanner is the ubiquitous flatbed scanner, so called because of its flat glass platen (or bed) that serves as both the scanning area and surface for laying down objects to be scanned. Most flatbed scanners are used for scanning reflective art.

Flatbeds can be accessorized to scan transparent originals. In fact, transparency adapters are especially useful for scanning large transparencies such as 4" x 5" chromes, medical X-rays and 2¼" negatives. Because flatbed scanners don't offer the high scanning resolution needed for the small 35mm format, dedicated slide scanners produce better scans of slides and color negatives.

A document feeder is another useful flatbed accessory, particularly when scanning for OCR. If you are scanning a book or lengthy document, a document feeder could pay for itself in one project because it allows many pages to be scanned at once without operator intervention. Not all scanner manufacturers offer document feeders. See the appendix for a list of current products.

If either of the above options will be important to you at a later date, be sure your scanner manufacturer allows you to purchase and install these accessories by yourself. Otherwise, you may have to send the unit back to be outfitted by the manufacturer. Also make sure your scanning software supports these features. For example, at the time of this writing the otherwise exemplary Ofoto doesn't support either transparency adapters or document feeders.

Flatbeds come in three types: entry-level, midlevel and high-end.

ENTRY-LEVEL flatbed scanners generally share the following specifications: 8½" x 11" scanning area, 300- to 400-spi scanning ability (often interpolated to 800, 1,200 or 1,600 "spi"), 8 bits per color channel and low cost. They often come bundled with powerful "value-added" software such as Adobe Photoshop. These machines

frequently offer excellent price/performance ratio. Because there is fierce competition for this market, at the time of this writing the magic price for entry-level scanners seems to be hovering around the $1,000 mark.

Entry-level scanners are adequate for capturing line art, for optical character recognition, and for FPO (for position only) scanning. For professional-looking color output, you may want to consider at least a midlevel scanner.

MIDLEVEL flatbed scanners differ from their entry-level cousins in three important ways: First, they cost much more! Second, because they're targeted toward a more professional market, they rarely come bundled with "value-added" software such as Photoshop. Third, and most important, they have significantly better specifications. For example, a typical midlevel flatbed scans at 600 x 1,200 spi and 10 bits per color, resulting in scans of significantly higher quality. Some midlevel scanners may also offer a larger scanning area. They typically run from $3,000 to $10,000.

Midlevel Flatbed Scanner.

HIGH-END flatbed scanners are positioned as alternatives to drum scanners. They offer features that professionals demand: noise-free design, large scanning area, high dynamic range and high resolution. Expect to pay a premium price of $10,000 to $20,000 for these scanners. Midlevel scanners are increasingly taking over this territory. Expect the lines to blur between midlevel and high-end flatbeds in the near future.

Transparency Scanners

Transparency scanners come in two versions: multiformat and 35mm.

MULTIFORMAT transparency scanners allow you to scan everything from 35mm slides all the way up to 4" x 5" transparencies. These scanners are targeted to professionals only and thus cost quite a bit, as much as $20,000. In fact, these high-end transparency scanners are muscling in on the once exclusive domain of drum scanners by offering more features, better software and faster scanning time.

35MM transparency scanners, also known as slide scanners, are used to capture both 35mm slides and negatives. Generally, negatives come in strips of film while slides are mounted in cardboard sleeves. Most slide scanners allow you to scan both types. While slide scanners used to be priced for professionals only, recent models introduced by Nikon, Microtek and Polaroid are targeting a broader market. Newer models even offer 10-bit scanning for under $2,500. On the high end, models such as Leafscan 35 and Nikon's LS-3510 generic "base" unit offer 12- and 14-bit scanning, autofocus and advanced scanning software not found on the lower-price models.

Most transparency scanners are, by definition, midlevel devices. Dedicated to scanning transparencies and negatives, they differ from flatbed transparency adapters in several important ways:

- They offer significantly higher scanning frequencies—usually on the order of 1,850 to 4,000 samples for the width of a 35mm slide (the area of which is 24mm x 36mm). This translates into a sampling frequency of 1,300 to 2,822 spi.

- They offer superior software algorithms for capturing the subtle differences between different transparency types and color negatives. Because film companies such as Kodak and Fuji manufacture their films differently for consumer and professional use, this can be a significant feature. Your sunsets look great when shooting Kodachrome because "amateur" films like Kodachrome and Fujichrome are oversaturated to give "truer" reds and greens. Ironically, Kodak's and Fuji's professional E6 films are nearly indistinguishable— they don't want to unduly influence a professional photographer's results.

SLIDE VS. FLATBED
As you can see from this comparison, dedicated slide scanners can discern differences in film types and are able to compensate for film differences to achieve the best quality.

Kodachrome slide scanned on flatbed with transparency option.

Kodachrome slide scanned with dedicated slide scanner.

Dedicated slide scanners have to know how to distinguish between these two film types. As a result, most transparency scanners come with a fairly complete list of different film types that the scanner software supports and can thus compensate for when scanning.

- Slide scanners cost a lot more than the relatively inexpensive flatbed transparency option. For those who may need only an occasional transparency scanned, a flatbed with transparency adapter is the way to go. But if you scan a lot of transparencies, only dedicated transparency scanners offer the best quality scans.

Slide Scanner.

Video Digitizers

Today, most people use video digitizers for multimedia purposes, especially in the creation of QuickTime movies. But that shouldn't prevent you from occasionally using them to capture still images for print.

Video cameras utilize the same digital CCDs found in flatbed scanners. The difference is that video cameras use CCD matrices instead of arrays and can capture an entire image at once, without scanning line-by-line. Video cameras produce an analog signal that drives other analog devices such as VCRs and television sets. Although video cameras technically aren't "scanners" in the truly digital sense of the word, the analog video signal can be redigitized using specialized hardware and software in your computer. Video-capture software is very similar to traditional scanning software, while the hardware is usually a board that fits inside your computer.

Although video cameras provide an inexpensive way to get images into your computer, you should be aware that the resolution is low (only 640 x 480 pixels) and the dynamic range is low (usually less than 2.5). The color accuracy is also suspect. Nevertheless, video cameras are more than competent—in fact, I've been using them for image capture in my own work since 1987.

Video Capture at 640 x 480 pixels.

Stand-Alone Oversize Digitizers

For very large originals up to 40 inches wide (such as architectural/engineering drawings), several manufacturers offer oversize, sheet-fed digitizers. These unusual devices are somewhat related to the automatic document feeders for flatbed scanners in that the original is pulled through the scanning mechanism. They differ in that the scanner head is stationary; in fact, they often bear a striking resemblance to CAD pen plotters. Because of the large image area involved, and subsequent large file size, sheet-fed digitizers usually can scan only in line art and grayscale modes. Because of their uniqueness and specialization, these devices are also quite expensive, ranging from $10,000 to $20,000 or more.

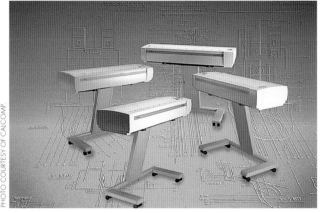

Stand-alone Digitizer.

Miscellaneous

- In a category by itself, Leaf's Lumina camera/scanner is an unusual piece of equipment. Although it appears to be a digital camera, the Lumina is actually a scanner. It uses standard Nikon bayonet lenses, which give it the same flexibility as an ordinary camera. It scans at 2,700 x 3,400 samples and 36 bits deep and can be mounted on a copy stand to scan flat art and books. By attaching a Nikon slide duplicator, the Lumina can scan slides into Photoshop. You can even use it as a studio "camera"; however, flash units won't work with the Lumina since it scans by imaging line by line. At $6,900, the Lumina may obviate the need to buy both a slide scanner and a flatbed scanner.

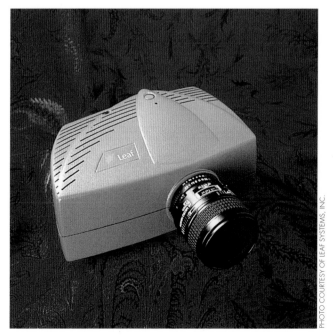

Camera/Scanner.

- A pocket-sized device from Trio Information Systems allows you to convert any fax machine into a 1-bit scanner or printer using a standard fax modem and proprietary Trio software. While certainly not high end, such a device may be particularly useful for those using laptops and portables on the road.

- It scans, it faxes, it prints! The 2001 Knowledge System from QMS is an all-in-one document processor offering 1-bit, 400-spi scanning, 8-pages-per-minute printing, and 2,400-bps (bits per second) faxing. There has been speculation for many years that all-in-one devices would gain in popularity, but most people still seem to prefer dedicated equipment to the multipurpose approach. But for those who have limited space, this may be just the ticket.

- Talk about specialized scanning! Pacific Crest Technologies offers a business card scanner (CardGrabber) that does just what its name implies—it is dedicated to those people who need to input and file tons of business cards! Who knows? It may be just for you.

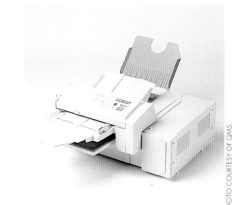

Multipurpose Scanner.

Photo CD

OK, OK, Photo CD isn't really a type of scanner, but it is a useful way of getting images into your computer. All you need is a CD-ROM drive hooked up to your computer and a roll of film you'd like to look at. Simply send the roll of film out to an authorized Kodak Photo CD developer and for about $1.00 to $3.00 per image you get your film developed along with a CD-ROM containing your digitized images! Pretty neat, huh? Plus CD-ROMs are a great way to keep your image files organized. The quality of these scans is quite good and the proprietary Photo CD format contains several sizes of each individual image for various uses. The largest size, 2,048 x 3,072 samples, is just large enough for a full-bleed 8½" x 11" image at 225 spi. It also happens to be the same dimensions as the proposed HDTV (high definition television) specification—a coincidence? You can probably get a better scan by using a dedicated slide scanner (see page 37) and not compressing the resulting image. However, if you don't want to buy a slide scanner and learn how to use it, Photo CD may be your best option.

Drum Scanners

Professional color trade shops wouldn't think of using anything less than a drum scanner for producing color separations for high-end printing. Instead of using CCD technology, drum scanners use PMT (photo multiplier tube) technology for greater dynamic range and color accuracy. They also cost an arm and a leg, ranging from $25,000 to $200,000. Nevertheless, drum scanners offer features not available to desktop scanners, such as direct conversion to CMYK, auto sharpening, batch scanning, greater dynamic range, and huge image scanning areas. Ironically, most drum scanners don't support preview mode—drum scanner operators are more interested in numbers than what they see with their eyes. Yet what truly sets drum scanners apart is their increased productivity. Since the process of scanning to CMYK is automated, drum scanners can produce more scans per hour than a desktop unit.

Digital Cameras

Digital cameras allow you to shoot three-dimensional objects, much like a regular camera, except you don't have to wait for film developing and processing. Portable units are presently limited in storage and image size. Studio-only units offer larger image size and dynamic range but require attachment to a host computer—hardly a portable solution. In the future, high-resolution, high-quality portable units will surely come—they just aren't here now.

Previous incarnations of "digital" cameras weren't really digital. They digitally sampled the analog signal from a CCD matrix as opposed to converting it to digital data. The resulting data was then stored on floppy disk. The floppy disk then had to be read by a special reader which converted the digital data back into an analog signal, which then had to be redigitized using a video digitizer (see page 38)—what a mess! As you might suspect, the quality wasn't much to write home about, either.

Newer entry-level digital cameras, such as Apple's QuickTake 100, are truly digital; i.e., they keep the signal (nearly) purely digital all the way from the CCD to the floppy disk to the computer. The secret is that they use massive compression of the digital data to get it all to fit on a floppy disk. Typically, these devices save from seven to thirty-two "frames" of digital data at up to 640 x 480 samples and 24-bit depth. The quality is quite good—good enough for small (2½" x 3½") reproductions in print and certainly good enough for many multimedia purposes.

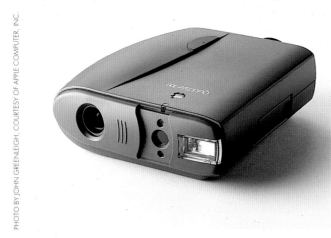

PHOTO BY JOHN GREENLEIGH, COURTESY OF APPLE COMPUTER, INC.

Digital Camera.

More expensive midlevel digital cameras such as Kodak's DCS 200 use higher resolution CCD panels (1,012 x 1,524 samples) and high-capacity micro hard disks to store the images. The DCS 200 also uses compression to squeeze all that data onto the hard disk. Optional features include digital modems for sending the images back to a "home" office.

High-end digital backs, such as the Leaf Digital Back for Hasselblad and Mamiya cameras, use even higher resolution CCDs (2,000 x 2,000 or more), higher bit depth (12 bits/sample), higher dynamic range, no compression, and high-speed cables connecting the device directly to a computer, where the image is stored and manipulated. Typically, these digital backs attach to a studio camera much as a Polaroid back does. The price of these high-end devices remains in the exclusive domain of professional photographers, and, as you might suspect, the quality is quite good.

Fortunately, the cost of these digital marvels is going down. I predict devices such as these will eventually outsell traditional film cameras—and for good reason: They are convenient, fast, quiet to operate, environmentally friendly and fun to use.

Handheld Scanners

Hand scanners are useful for their portability and low price—often a third to a quarter of the cost of a flatbed scanner. Hand scanners generally plug into a computer's printing port, as opposed to a SCSI port, allowing them to be shared from workstation to workstation. Many people find them ideal for use with a notebook or laptop. Unfortunately, hand scanners are less accurate than flatbeds because they have weaker light sources and often produce uneven scans—

PHOTO COURTESY OF LOGITECH INC.

Hand-held Scanner.

courtesy of the unsteadiness of your hand or the surface you're standing on. Many hand scanners now offer an alignment template to help guide you when scanning. At least one manufacturer ships a motorized "self-propelled" unit to help stabilize its scanner.

High-end hand scanners offer 400-spi resolution and 24-bit color, allowing you to achieve reasonably high-quality results. But their 4"- to 5"-wide scan head forces you to make multiple passes to scan even average-size documents. You use the stitching software supplied with these scanners to merge the partial scans together—a time-consuming task. Nonetheless, hand scanners are very popular and are capable of high-quality, quick and easy, low-cost scans.

Types of Scans

Scanning for Screen

Increasingly, images are being scanned for multimedia purposes (i.e., computer display) as well as multiple media (computer display, digital prints, slides and print). For multiple media it's inappropriate to optimize an image for print, a procedure that can be done later. At the time of scanning, it's more important to capture as much data as possible at the highest possible gamut. For multiple media purposes, you need to scan an image to match the high resolution needed for print while also optimizing for the high color gamut of the computer screen.

A major problem with computer monitors is their lack of consistent color. The endless combination of cards and monitors also makes it impossible to predict the final image display size. This is particularly true on PCs since no standard yet exists for color management under Windows. Windows also has no way of knowing what kind of monitor is attached or what size it is.

The Macintosh is far more predictable because the cable that connects the monitor to the computer (generally) informs the system what size display is being used. Most Macintoshes display at around 72 ppi—although there are exceptions. Color management on the Macintosh, while worthy of kudos, is not as true or consistent as it could be.

Most monitors can display at least 256 colors (8-bit); in fact, 8-bit color can be found on almost all bargain-basement computers. However, 8-bit color needs to be

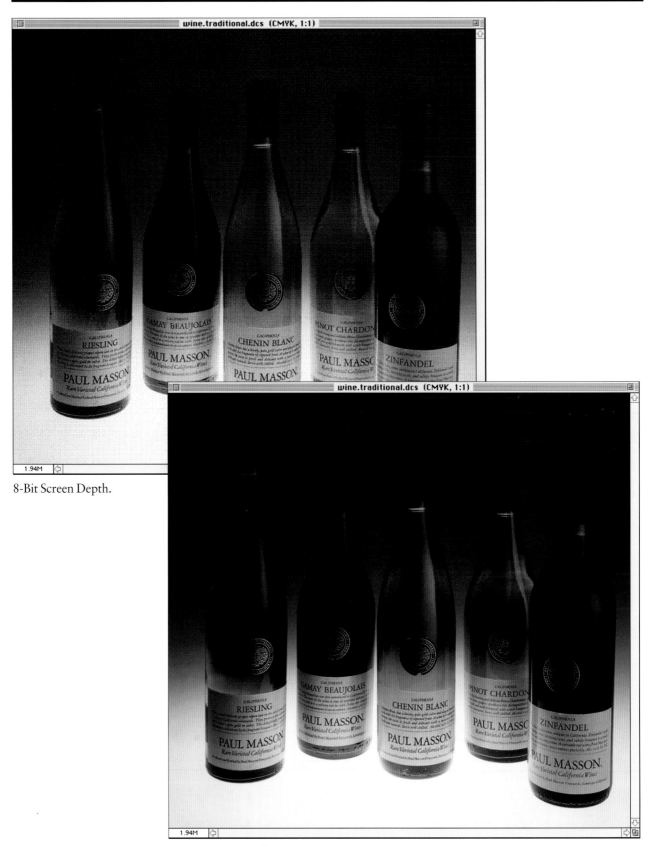

8-Bit Screen Depth.

16-Bit Screen Depth.

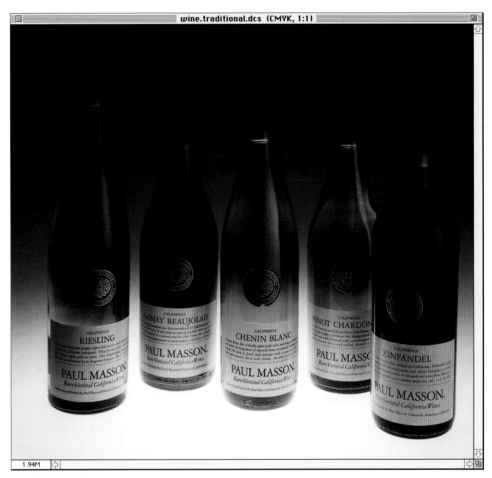

wine.traditional.dcs (CMYK, 1:1)

1.94M

24-Bit Screen Depth.

dithered, making photos on these monitors somewhat "grainy." But if 8-bit images are adequate for your needs (such as multimedia presentations), they are the most compatible across various systems—especially those that use the System Palette. Eight-bit images also take up very little disk space. For example, a 640 x 480 pixel, 8-bit image is only 300K in size, while a 640 x 480 pixel, 24-bit image is 900K—three times the size of the 8-bit image!

Fast becoming the multimedia standard are 16-bit depth computer monitors. Sixteen-bit displays are capable of 32,000 simultaneous colors (three 5-bit RGB channels plus one extra bit). Not only is 16-bit significantly better looking than 8-bit, it also displays a lot faster than 24-bit; in fact, in most cases, 16-bit images are indistinguishable on screen from equivalent 24-bit images. Someday all computer screens and high-definition televisions may be 24-bit. But in the meantime, 16-bit will become the universal cross-platform standard for the foreseeable future.

Of course, the granddaddy of all computer monitors is the big, 24-bit display. Although the size of 24-bit files (and the price of 24-bit display equipment) is enormous, nothing looks quite as good as a high-resolution 24-bit image—it is the closest you can come to the beauty and depth of a 35mm slide. However, it should be noted that this depth doesn't translate as effectively in print. Offset presses just can't print all the colors you see on screen. If you

SCREEN SIZE	PIXEL DIMENSIONS OF SCREEN	APPROX. PIXELS PER INCH (PPI)
8.5" (LCD)	640 x 480	94
9"	512 x 342	72
12"	512 x 384	63
	640 x 480	79
13"	640 x 480	72
	800 x 600	90
14"	640 x 480	66
	800 x 600	82
	832 x 624	86
15"	640 x 480	61
	800 x 600	76
	832 x 624	79
	1024 x 768	98
16"	640 x 480	57
	800 x 600	71
	832 x 624	74
	1024 x 768	91
17"	800 x 600	66
	832 x 624	69
	1024 x 768	85
19"	800 x 600	58
	832 x 624	61
	1024 x 768	75
20"	1024 x 768	71
	1152 x 870	79
21"	1024 x 768	67
	1152 x 870	75

Use this table for calculating final sizes of scanned images for screen display.

find yourself wanting to print a 24-bit image, consult Photoshop's Gamut Alarm in the Color Palette to see which colors won't reproduce effectively on press.

For information on FPO and halftone scanning see page 5.

Scanning for OCR

Most OCR software is optimized for 300 spi and 1-bit black and white. 300 spi is more than enough resolution to distinguish normal text on a page. OCR software relies on pattern matching instead of raw resolution. Thus, using grayscale or a higher sampling rate only slows things down without providing much (if any) increase in accuracy.

Scanning for Autotracing

For autotracing purposes, only one thing counts—the highest possible resolution. Autotracing algorithms attempt to match the best possible curve to a jagged bitmap outline. Thus, the more bits, the better the matching. If you are stuck with a low-resolution scan, you may want to try the increased resolution technique shown on page 80, before having it autotraced.

WHEN AUTOTRACING, SCAN AT A HIGH RESOLUTION

Autotraced copy of an image scanned at 600 spi.

Autotraced copy of the same image scanned at 200 spi.

Types of Scanning-Related Software

Plug-Ins

Plug-in software refers to any application (often called an "applet") that can be launched from within another "host" program. Examples of host programs are Photoshop, QuarkXPress and Streamline. Examples of plug-ins are the vast majority of scanning applications.

Most scanning software today is either TWAIN or Photoshop Acquire compatible. Add-in utilities that utilize such standards can deliver the scans right where you need them most—in your favorite image-editing program.

Scanning plug-ins control your scanner and allow you to crop, size, and correct for color, tone, contrast and lightness. The following plug-in options help you clean up, color correct, and apply special effects to an image "post-scan" within a dedicated image-editing program:

- Special effect filters such as Kai's Power Tools and Aldus Gallery Effects can add all sorts of photographic, fractal and painterly effects to your images after you scan.

- Noise-reduction plug-ins shipping with Agfa scanners and others allow you to reduce noise in your scans (as well as in scans supplied to you). It's generally better to use these plug-ins sparingly, for example, in the shadow areas only.

- Import/export/acquire filters allow you to export or import an image with a unique file format.

- Image enhancers such as MonacoColor and Intellihance analyze an image by looking for statistical relationships within the data and modifying the image to provide optimal density, exposure, saturation and sharpness.

- Scanner calibration packages such as Color Encore and ColorAccess (see below) provide color calibration on the fly from within Photoshop—important for quality work since your scanner changes slightly from month to month and even from day to day. Calibration software scans a known target and creates new lookup tables.

- Agfa's FotoTune CMYK Photoshop ColorLinker provides better RGB-to-CMYK conversions than Photoshop's internal algorithms.

- EfiColor tables for Photoshop replace Photoshop's own lookup tables for RGB-to-CMYK conversion.

System Level Software

There are a number of system-level programs out there offering color correction capabilities. These programs, called color management systems (CMS), enable your system to calibrate itself so that the colorspace defined by the scanner is correctly mapped to the colorspace available on the monitor, which, in turn, is correctly mapped to the output device. In effect, using a CMS allows all the devices to process color in a

definable, predictable manner. Here are descriptions of some of the more popular CMS options available at the time of this writing.

- Apple's ColorSync has quietly become the standard color management platform upon which to build more comprehensive solutions. ColorSync provides the basic building blocks needed for all applications and hardware to "talk" to one another using the same colorspace language. Because Windows 3.x doesn't offer equivalent system-level color management, the Macintosh has established an enormous lead in regards to high-end color management solutions. It's rumored that ColorSync will eventually be available to Windows users.

- Pantone and Light Source have teamed up to provide one of the most comprehensive color management systems around. Pantone Open Color Environment (POCE) is designed to match both continuous tone images (using Light Source's AeQ) as well as spot colors (i.e., the ubiquitous Pantone Matching System, or PMS). All current licensees of Pantone colors (Quark, Aldus, Adobe, Altsys, Corel, etc.) will be allowed to ship AeQ with their products without additional charge. This could make POCE a major contender in the CMS world.

- Electronics for Imaging was one of the first manufacturers to provide a standard color model and color language for scanners, monitors and output devices. The downside to EfiColor is that it's expensive—each device needs a custom (and costly) profile. Recent bundling has reduced the individual costs substantially, but EfiColor remains a unique and proprietary solution.

- Kodak signed deals with Adobe, Aldus and others to license its version of a CMS, which they call KCMS. Although promising, KCMS has yet to prove its mettle since it is currently incompatible with other CMS solutions. If you own one of Adobe's or Aldus's products, such as Photoshop or PageMaker, you probably have a KCMS folder sitting somewhere on your computer taking up space and waiting to be utilized.

- Agfa's FotoFlow color management system allows you to characterize your scanner by comparing a scan of an IT8 test target to supplied reference data, and then it builds a conversion linker to the RGB or CMYK output of your choice. Like KCMS, it is currently incompatible with other CMS solutions, but Agfa and most of the other CMS developers have promised to be ColorSync 2 compatible, thus paving the way for future compatibility.

File Formats & Storage

Types of File Formats

When saving images, the file types used most are TIFF and EPS. All image-editing applications, and most scanning software, support these two formats:

TIFF (tagged image file format) is probably the most widely used bitmapped file format. It can be imported into a wide variety of page layout, image-editing, illustration, and even word processing programs. It works for all types of images, line art and halftones as well as color or grayscale, and it can have a bit depth of 1, 4, 24 or 32 bits. There are Mac and PC versions as well. Version 4.0 of the TIFF specification is the most compatible, while version 5.0 offers added compression and higher bit depths. The upcoming version 6.0 specification allows for high-fidelity color and even greater compression. Although TIFF images are extremely versatile, older programs sometimes aren't able to import files using newer versions of the TIFF specification.

EPS (encapsulated PostScript) is as popular as TIFF for saving image files and it works for as many types of images as TIFF. EPS files can be imported into nearly every kind of application from page layout to word processing. EPS is commonly specified when converting an RGB file to CMYK to create five-color separation files—one for each of the four process colors and one for position only. This five-file EPS format is also known as DCS (digital color separation). EPS is also very useful for saving RGB files that need to be output to slide recorders. Its main drawback is that EPS takes up more disk space than any other format.

BMP (short for bitmap) is a basic, no-frills, Windows-only format that's generally used for screen display. Most Windows C programs can use BMP files when compiling applications to run on Windows computers. For this reason, most Windows applications support this format.

PICT (short for picture) is a proprietary Mac format generally used for screen display only. Some Mac programs, such as Adobe Illustrator and Macromedia Director, can only import images saved as either PICT or EPS. Because it doesn't provide information for separations, PICT shouldn't be used for printed images.

JPEG (Joint Photographic Experts Group) is a compression format that makes very compact files and is a great way to exchange data with your clients and vendors because its small file size allows speedy transmission via modem. However, this option

definable, predictable manner. Here are descriptions of some of the more popular CMS options available at the time of this writing.

- Apple's ColorSync has quietly become the standard color management platform upon which to build more comprehensive solutions. ColorSync provides the basic building blocks needed for all applications and hardware to "talk" to one another using the same colorspace language. Because Windows 3.x doesn't offer equivalent system-level color management, the Macintosh has established an enormous lead in regards to high-end color management solutions. It's rumored that ColorSync will eventually be available to Windows users.

- Pantone and Light Source have teamed up to provide one of the most comprehensive color management systems around. Pantone Open Color Environment (POCE) is designed to match both continuous tone images (using Light Source's AeQ) as well as spot colors (i.e., the ubiquitous Pantone Matching System, or PMS). All current licensees of Pantone colors (Quark, Aldus, Adobe, Altsys, Corel, etc.) will be allowed to ship AeQ with their products without additional charge. This could make POCE a major contender in the CMS world.

- Electronics for Imaging was one of the first manufacturers to provide a standard color model and color language for scanners, monitors and output devices. The downside to EfiColor is that it's expensive—each device needs a custom (and costly) profile. Recent bundling has reduced the individual costs substantially, but EfiColor remains a unique and proprietary solution.

- Kodak signed deals with Adobe, Aldus and others to license its version of a CMS, which they call KCMS. Although promising, KCMS has yet to prove its mettle since it is currently incompatible with other CMS solutions. If you own one of Adobe's or Aldus's products, such as Photoshop or PageMaker, you probably have a KCMS folder sitting somewhere on your computer taking up space and waiting to be utilized.

- Agfa's FotoFlow color management system allows you to characterize your scanner by comparing a scan of an IT8 test target to supplied reference data, and then it builds a conversion linker to the RGB or CMYK output of your choice. Like KCMS, it is currently incompatible with other CMS solutions, but Agfa and most of the other CMS developers have promised to be ColorSync 2 compatible, thus paving the way for future compatibility.

Stand-Alone

Dedicated stand-alone software is set up this way because it is simply too complex to launch from a host program. Most stand-alone applications are unique products offering highly specialized features. Be aware that running these programs concurrently with other programs requires a computer setup with lots of RAM, large hard disks, and a multitasking operating system like Windows NT, UNIX, or System 8.0 for Macintosh.

- Savitar ScanMatch (now owned by EFI) calibrates your system by using a supplied Pantone target and any Photoshop Acquire-compatible scanning application. Simply scan the target into ScanMatch, and the software creates a calibrated lookup table. Subsequent calibrations can take place within Photoshop using a ScanMatch plug-in.

- Ofoto from Light Source is one of the most powerful, automated, closed-loop scanning applications available. Most plug-in scanner applications pale in comparison. It supports many popular desktop scanners, but not all.

- Fractal Design Painter and Fauve Matisse offer unique painterly image-editing tools not available anywhere else—everything from van Gogh effects, to watercolor, to "blobs" that distort an image in unique and unusual ways.

- Live Picture from HSC is unique in that it uses a special mathematical file format called FITS that allows users to open 200MB images in about ten seconds! What's more, Live Picture offers unlimited layers and infinite resolution. Final, placeable, printable images are RIPped (to TIFF or EPS) from within Live Picture to match the exact resolution of the intended output device. Live Picture requires at least 64MB RAM, a host machine, and lots of hard disk space!

- Apple's PhotoFlash provides automatic tools for eliminating scratches and dust from your scans. It can also automate repetitive tasks such as rotating, sizing, color cast removal and cropping by using Apple Events for batch processing of your files.

- In my opinion, Cachet from EFI is one of the most intuitive color correcting applications ever created. EFI also comes with a collection of subject files with matching prints. By subjectively color matching your image with a similar one from the file, you can eliminate the need for a calibrated monitor!

- PixelCraft ColorAccess is a full-featured color correcting/separation utility. It's popular with professional color separators because it uses terminology and

controls they are familiar with. By and large it supports midlevel and high-end scanners, but your scanner may be supported as well. It also comes bundled with high-end scanners such as the Sharp JX-610 and the Xerox/PixelCraft Pro Imager 8000.

OCR

Optical character recognition (OCR) software is the workhorse of office scanner tools. As its name implies, OCR software uses the bitmap image generated by a scanner to capture an "image" of a page of text and, using complex pattern-matching algorithms, interprets the series of scanner samples into individual letterforms. The result is a page of (mostly) accurate text.

OCR works best with unkerned, amply leaded body text. Dot-matrix and fax input text can confuse even the best OCR software. Although some high-end OCR applications boast of 99 percent accuracy, be forewarned: This means that a typical page of text (2,000 to 3,000 characters) may have twenty to thirty errors—errors you have to fix manually or catch later with a spelling checker.

Look for learning capability so that your OCR setup can obtain better results over time using your specific combination of scanner and input text style. Also look for automatic document feeder support if your scanner has that option.

Utilities

There are beaucoup utilities out there for scanner operators. Most offer complementary functions to those that are standard for image-editing and scanning programs.

- Adobe Streamline is the best raster-to-vector (also known as autotrace) conversion utility out there for desktop systems. Not only does it work with black-and-white and grayscale images, it also converts color image files into line art, with unique and pleasing results. Because it supports Photoshop plug-ins, you can scan directly from within Streamline.
- Sizing calculators, available as downloadable shareware from major bulletin boards, can assist you in determining the optimal size parameters to use for scanning without guesswork.
- DeBabelizer from Equilibrium Technologies imports, converts and exports more than forty-five image file formats from the Mac, PC, Amiga, Apple II, Photo CD and Silicon Graphics computers.

File Formats & Storage

Types of File Formats

When saving images, the file types used most are TIFF and EPS. All image-editing applications, and most scanning software, support these two formats:

TIFF (tagged image file format) is probably the most widely used bitmapped file format. It can be imported into a wide variety of page layout, image-editing, illustration, and even word processing programs. It works for all types of images, line art and halftones as well as color or grayscale, and it can have a bit depth of 1, 4, 24 or 32 bits. There are Mac and PC versions as well. Version 4.0 of the TIFF specification is the most compatible, while version 5.0 offers added compression and higher bit depths. The upcoming version 6.0 specification allows for high-fidelity color and even greater compression. Although TIFF images are extremely versatile, older programs sometimes aren't able to import files using newer versions of the TIFF specification.

EPS (encapsulated PostScript) is as popular as TIFF for saving image files and it works for as many types of images as TIFF. EPS files can be imported into nearly every kind of application from page layout to word processing. EPS is commonly specified when converting an RGB file to CMYK to create five-color separation files—one for each of the four process colors and one for position only. This five-file EPS format is also known as DCS (digital color separation). EPS is also very useful for saving RGB files that need to be output to slide recorders. Its main drawback is that EPS takes up more disk space than any other format.

BMP (short for bitmap) is a basic, no-frills, Windows-only format that's generally used for screen display. Most Windows C programs can use BMP files when compiling applications to run on Windows computers. For this reason, most Windows applications support this format.

PICT (short for picture) is a proprietary Mac format generally used for screen display only. Some Mac programs, such as Adobe Illustrator and Macromedia Director, can only import images saved as either PICT or EPS. Because it doesn't provide information for separations, PICT shouldn't be used for printed images.

JPEG (Joint Photographic Experts Group) is a compression format that makes very compact files and is a great way to exchange data with your clients and vendors because its small file size allows speedy transmission via modem. However, this option

uses lossy technology to compress files, so you may want to save a master version of the file before saving it as a JPEG image. (See Compression below for an explanation of lossy technology.)

PCX is an early low-end PC standard that is still being used today by some image-editing programs such as Windows Paint and PC Paintbrush. Because of its early adoption, many other Windows applications support this format.

TARGA is an early high-end PC standard developed by AT&T. Although quite popular with video editing and multimedia, it hasn't gained wide acceptance in the prepress field mostly because of the overwhelming popularity of TIFF and EPS.

PHOTOSHOP NATIVE Quite a few image-editing programs now support the Photoshop native file format, including Fractal Design Painter and Aldus PhotoStyler. Photoshop native files take up less space than uncompressed TIFF files and are faster to open and save than compressed TIFF files. Photoshop native also allows you to save masks, clipping paths and alpha channels.

Compression

You need to compress large images whenever you run out of room on your hard disk. If you use your scanner as much as I do, you may run out of hard disk space on a daily basis! You may also find it convenient to compress images to send files to your clients and vendors, particularly via modem. There are two types of compression available to you: *lossless* and *lossy*.

LOSSLESS compression does just what it implies—nothing is lost during compression. Using mathematical algorithms that eliminate redundant data, lossless compression often provides significant compression with reasonable performance. Examples of lossless compression are Photoshop native format, TIFF 6.0, and compression utilities such as StuffIt and PKZIP. Some files have very little redundant data, so compressing them with a lossless scheme can actually increase the file size! Lossless compression is often used when archiving a file for backup. In fact, backup software such as Retrospect offers both software and hardware compression (if available on that particular device) when archiving.

LOSSY compression offers even greater image compression. The trade-off is that it results in loss of data during the compression process. The theory is that certain data is not important in an image and consequently is expendable. In practice, you can usually tell if a file has been compressed with a lossy scheme by examining flat color areas near

the border of transitional colors. Depending on the original and also on how much compression you specify (high, medium or low), the effect can be subtle or irritating.

However, results are often gratifying. I recently compressed an image using JPEG from 3MB to 300K! By using JPEG compression in the Quality = Good mode, I was able to reduce the file size significantly while retaining nearly the same quality the image had without compression. You'd be hard-pressed to tell the difference (see figures on page 55). I was able to quickly send this low-memory file via modem to my service bureau for color prints, as well as to my client for approval. The file transfer took one-tenth the time it would have if I hadn't compressed it.

Lossy compression is very popular with multimedia professionals–most notably when delivered by Apple QuickTime–and like it or not, it's here to stay.

Lossy Compression

This setting was used to reduce the file size using JPEG compression.

Compressed to 90K, this image is of fair quality.

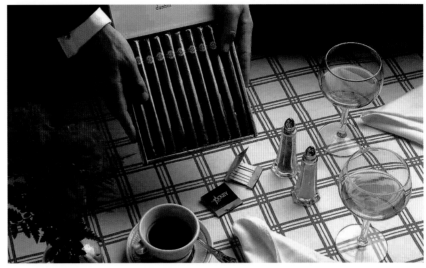

Compressed to 270K the same image is far more acceptable.

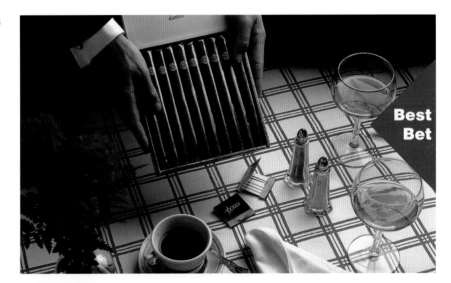

At 1,040K, this compression yielded excellent results; however, for obtaining client approval over the modem, the smaller 270K file is perfectly acceptable.

Calibrating Your System

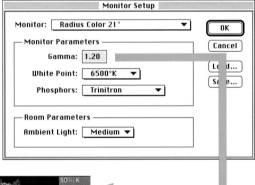

Figure 1: The Gamma Control Panel.

If you don't own one of the proprietary color management systems described earlier in this chapter, be prepared to roll up your sleeves and do a lot of grunt work. Here's how to do a basic system calibration with Photoshop:

Step 1

Launch Gamma (supplied with Photoshop) from the control panel. Set the Gamma to 1.8. Adjust the slider until the gray bar is of a smooth, continuous tone. Adjust the White Point and Balance to compensate for any color cast your monitor may have. Save the settings. Quit.

Step 2

Launch Photoshop. Load the CMYK file Olé No Moiré (supplied with Photoshop). Under File/Preferences, choose the Monitor Setup dialog box. Choose your monitor

Figure 2: The Monitor Setup dialog box under File/Preferences.

and manufacturer from the list, or choose default if yours isn't listed. Click OK. Make sure the Colors dialog box is open and RGB is selected. Use the Eye Dropper tool to select the upper right-hand 50 percent gray area of Olé No Moiré.

Step 3

The RGB colors should be exactly 128, 128, 128. If not, go back to the Monitor Setup dialog box and adjust the Gamma setting up or down so the gray reading of the CMYK file in RGB colors is as shown in the Olé No Moiré image. Go back one more time to the Monitor Setup dialog box and save your settings as MyMonitor.Settings.

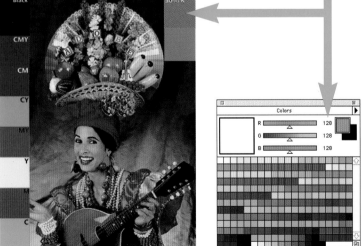

Figure 3: The Olé No Moiré image. Figure 4: The Colors palette.

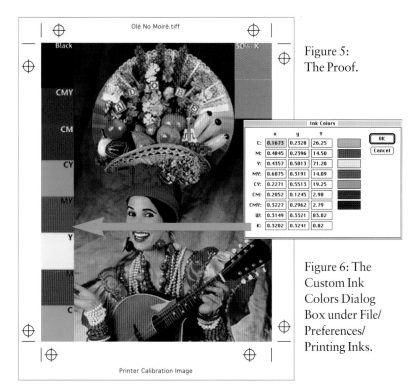

Figure 5: The Proof.

Figure 6: The Custom Ink Colors Dialog Box under File/ Preferences/ Printing Inks.

Step 4

Choose Printing Inks Setup under File/ Preferences. Set the printing inks to SWOP if you intend to print to an offset press.

Step 5

Choose Separation Setup under File/ Preferences. Select GCR unless you are printing on newsprint.

Step 6

Load into Photoshop an RGB scan you want to separate. Adjust the image so it looks good on your now-calibrated monitor. Change Mode to CMYK, to create separations using your specific calibration settings. Use the Levels command to adjust for press conditions, such as dot gain. Save the file as a TIFF or five-file EPS file. Also save Olé No Moiré as a TIFF or five-file EPS file. Place both images in your page layout program. Send the files to your service bureau and order an Iris Ink Jet or film separations with Matchprint proof (or equivalent).

Step 7

Compare the proof(s) with the image displayed on your monitor. If you have properly calibrated your monitor, the proof should be a good match to what you see on screen. If not, you may need to do one more step.

Step 8

Choose Printing Inks under File/Preferences. Select Custom Inks instead of SWOP and the Ink Colors dialog box will appear. Using a densitometer, enter the x, y and Y values (CIE color coordinates) taken from the proof for each of the seven colors shown.

If you don't have access to a densitometer, adjust the colors by eye. Click on each color patch and then adjust the color on screen until it matches your proof. Click OK and repeat for each color patch. Save your Printing Ink settings and reseparate your RGB file by converting the mode to CMYK. When you compare again, you should have an exact match.

CHAPTER THREE

The Scanner Workout

Ways to Eliminate Moirés

A moiré is a wavelike pattern that occurs whenever two or more regular patterns are superimposed on one another. Moirés occur when you attempt to scan something that has already been halftoned—an image that has already been printed in a magazine, newspaper, book, etc. (see Legal and Ethical Issues in chapter five for more information on what can and cannot be legally scanned and copied).

One way to eliminate a moiré is to use hardware and/or software that automatically rescreens an image during the scanning process. Light Source's Ofoto is one software solution that works especially well with halftones above 100 lpi. Another example is FotoLook, a scanning program with automatic sharpening and descreening that comes with the Agfa Arcus Plus scanner. It works particularly well with color halftone images. If you work with a lot of preprinted images, the "push-button" convenience of these packages may be well worth the investment.

For those of you who don't have either Ofoto or an Agfa scanner, you can eliminate the moiré in an image-editing program such as Photoshop using a variety of filters and sharpening. Halftone images all respond differently to scanning and sometimes only certain combinations of filters produce optimum results. Rest assured, the results are equal to and possibly better than the automatic solutions.

Don't expect to get more resolution or detail out of a halftone image than the lpi of the original. The best you can expect from your scan is to equal, but never improve upon, the original halftone.

A different kind of moiré occurs when you print black-and-white computer screen shots, particularly where a patterned background occurs. You can correct this by scanning the image at an spi number that is a factor of the final printed resolution. For example, if you're printing an image at a resolution of 1,200 dpi you should scan it at 75, 100, 120, 150, 200, 300, 400 or 600 spi. The trick is that these numbers all divide evenly into 1,200, and, thus, no moiré is introduced by the halftoning process. Manipulate the image in an image-editing program as described in this demo for eliminating moirés in traditional halftones.

Ways to Eliminate Moirés

ORIGINAL

This black-and-white photo of a computer chip was clipped from a high-tech brochure. It needs to be scanned, rescreened and reprinted at its original size.

Prescreened images should be scanned at an spi that is twice the halftone frequency or lpi of the halftone image. The optimum scan for an image clipped from a magazine is 266 spi, twice the typical 133 lpi of magazine halftone screens. A newspaper image should be scanned at 130 spi, or twice the typical 65 lpi of a newspaper halftone. Don't scan at a resolution higher than what's necessary to do the job, because the descreening process is optimized for a 2-to-1 sample rate. Besides, scanning an image at a resolution of more than 300 spi creates an unnecessarily large file and requires additional RAM to handle.

Because this image is a 150 lpi halftone, it should be scanned at 300 spi (a 2:1 ratio) and scaled at twice the size (200 percent) of the original to maximize detail and provide the best sampling rate for the descreening procedures depicted.

Using Photoshop's Gaussian Blur and Sharpening

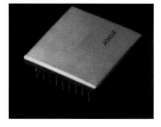

STEP 1

When the photo is first scanned, a significant moiré appears in the dot pattern.

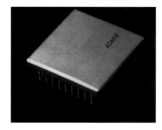

STEP 2

Apply the Gaussian Blur filter and Sharpening tool. Gaussian Blur works best when it is assigned a radius of 1.0 to 2.0 pixels.

Using Photoshop's Despeckle Filter

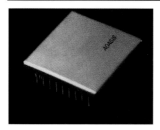

STEP 1

The Despeckle filter is applied to the same 2:1 scan used above. This results in a slight improvement. You can also try applying the Median filter, especially useful with color images. Halftone images respond differently to scanning. Sometimes only certain combinations of filters produce optimal results.

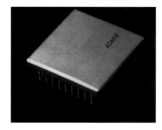

STEP 2

Apply a 50 percent scale reduction to the despeckled image and the results aren't bad. Although the final image seems as though it could benefit from some sharpening, don't try it. Because the Despeckle filter didn't actually get rid of the moiré, the Sharpening tool would only accentuate the noise.

Using Agfa Arcus Plus and FotoLook

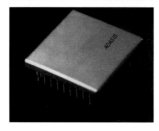

STEP 1

This 300-spi image is the result of selecting automatic sharpening and descreening before scanning.

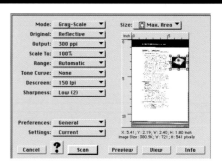

Descreening was set at 150 lpi and Sharpness was set at low.

Gaussian Blur

Radius: 1.5 pixels

OK

Cancel

STEP 2, continued
A setting too high, such as 3.0, destroys the detail in the image. Use 1.5 for most scanning applications.

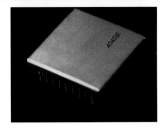

STEP 3
Reduce by 50 percent and apply the Sharpening tool again. The final image, output at the same size as the original clipping, has a resolution of 150 dpi.

Using Light Source Ofoto

STEP 1
Ofoto's one-touch control is a boon for anyone scanning lots of halftone images. This 300-spi image is the result of selecting the automatic descreening and sharpening features before scanning.

STEP 2
A 50 percent reduction yielded this 150-spi image. Additional sharpening was applied using Photoshop's Unsharp Mask filter. This combination tied with Agfa's FotoLook for giving the best results.

Tip

It's important to remember that thin, nonopaque paper allows whatever ink there is on the back to show through. To prevent this, use black paper behind your image when scanning. You may need to compensate for muddy or darkened whites created by the black paper showing through by adjusting the gamma or contrast levels of the image in your scanning software or later in an image-editing program such as Photoshop.

STEP 2
A 50 percent reduction to 150 spi plus sharpening in Photoshop yielded this halftone.

Finding Your Scanner's "Sweet Spot"

Most scanners have minor inconsistencies. Given this tendency, it should come as no surprise to realize there are some portions of the imaging area of your scanner that are better than others. If possible, you should space your image within this "sweet spot" to obtain the best and most consistent scans.

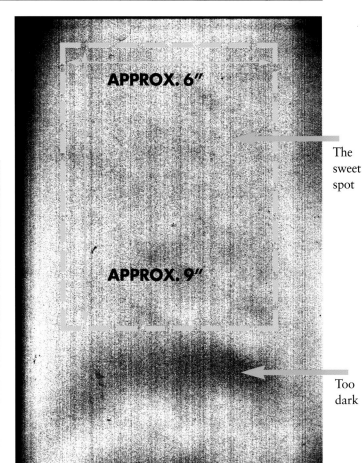

The sweet spot

Too dark

STEP 2
Bring the image into an image-editing program such as Photoshop and use the Equalize command to exaggerate any minor differences within the image area. As you can see, my scanner has dark spots on the edges as well as a bright streak on the left. The blotchy area about eleven inches down also is something I need to be aware of when scanning subtle images.

Once you've determined where your scanner's sweet spot is, you may want to make a cardboard template to aid you in future scanning.

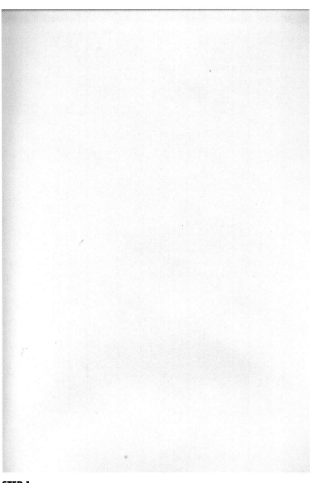

STEP 1
To find your own sweet spot, simply make a scan of the entire image area (my scanner's live image area is 8½" x 14") using a clean, white surface, such as a sheet of opaque paper, to scan. Set the resolution low, between 72 and 100 spi. (For this demo, there's no need to make a high-memory scan.)

Scanning at Higher Than Optical Resolution

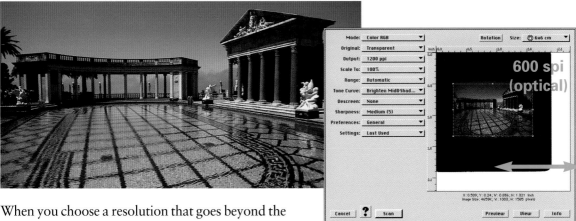

When you choose a resolution that goes beyond the stated optical resolution of your scanner, it's important to consider the orientation of your image before scanning.

Most flatbed scanners offer asymmetric optical scanning. (Slide scanners rarely offer this option.) For such flatbeds, typical "true" optical resolutions are 300 spi horizontal and 600 spi vertical. Higher-priced flatbeds may offer "true" optical resolutions of 600 spi horizontal and 1,200 spi vertical. Because your image-editing program needs square samples to work with, flatbed engineers resort to a sleight of hand: They interpolate the horizontal data up to match the vertical resolution, in effect "doubling" the horizontal data. As a result, when you scan beyond your scanner's maximum optical resolution, you're not getting "real" data but "best guess" or "faked" data for the horizontal data.

There is a way you can minimize this effect. When scanning at a higher than true optical resolution, be sure the longest dimension of your rectangular image matches the higher optical number. If you have an 8" x 10" photo, orient it on the scanner by aligning the longest dimension of the photo parallel to the dimension that has the higher optical resolution. For most scanners this is the vertical (sometimes referred to as "slower") dimension. Note: Square images generally aren't affected by orientation because there is no net gain to be made by rotating them.

The net result for a rectangular image with a length-to-width ratio of 2:1 is up to 25 percent more "real" data—even though the file sizes are the same!

When scanned with a horizontal orientation at 1,200 spi, most of this image's data is captured on its longest dimension at the scanner's maximum optical resolution of 600 spi. The resulting 1,200-spi visual is made from a 50/50 split of "real" and "faked" data.

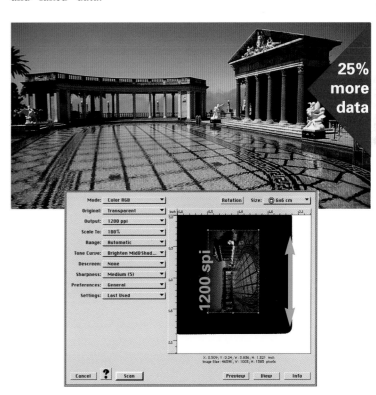

When rotated 90°, with its longest dimension on the vertical axis, and scanned at 1,200 spi, the same image is comprised of more "real" data because most of it was captured at the scanner's true optical resolution of 1,200 spi.

Scanning 3-D Objects

You can use your flatbed scanner to capture 3-D objects much as a camera would. (Assuming, of course, they fit on the glass platen!)

Shown here are just a few of the many things I have scanned over the years. What is particularly nice is how fast and easy it is to obtain "photos" this way. Plus, the images are yours—no rights need to be negotiated for any of your scanned "photos."

The obvious problem with scanning 3-D objects is lack of lighting control. Most flatbed scanners capture some of the dimensionality of an object by casting a slight shadow. (See the diagram of how a scanner works on page 2 in chapter one.) The direction of the shadow depends on the optics of your particular scanner and where the object is placed on the glass platen. You have to experiment with your scanner to see where shadows fall each time an object is repositioned.

SCANNING FOOD
The most important thing to remember is to clean up afterward. Other than that, you'll be impressed at how good food looks when scanned. The soft, natural shadows created by the scanner are very close to the effect of studio lighting.

SCANNING CYLINDRICAL OBJECTS
Before you begin to scan, prevent the object from rolling around by taping the back of it to a large piece of paper—in this case, I used white bristol board. The paper serves as the background of the object while it's being scanned.

STEP 1
Determine where you want the shadow to fall on your image by making a preliminary scan. Reposition the object and its backing on the scanning bed if the shadowed side of your image isn't exactly where you want it to be. To create a lighter shadow, apply additional lighting by positioning a light source (such as a table lamp) underneath the lid, close to the object, resting on the platen. Be careful when doing this—table lamps can get very hot!

STEP 2
Use channel masks in an image-editing program such as Photoshop to change the background. First mask the object by using the selection marquee and the option key to create a continuous selection path. When the object is selected, save the selection to a channel, invert it (to select the background region), and use the gradient fill tool to fill the background with a smooth blend.

STEP 3
The final result is equivalent to the effect of studio lighting at a fraction of the cost.

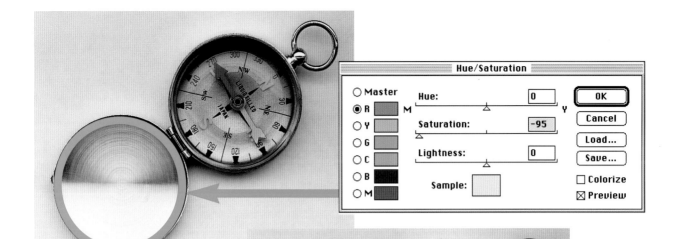

SCANNING METALLIC OBJECTS

Color scans of metallic objects inevitably produce rainbow patterns in some portions of your image, similar to what's shown above.

To remove the rainbow, bring your image into Photoshop and select the rainbowed regions. Open the Hue/Saturation controls and individually select the red, green and blue, reducing the saturation of each as shown.

Keep in mind that if you scan at 1,200 spi or more, you can enlarge any object for high-resolution output. This 1,200-spi scan of a dime, output at 600 percent and 133 lpi, yielded this highly detailed image. When you need a close-up of a tiny object, the scanner works much better than a camera with a macro lens—much faster, too.

Scanning Great Background Effects

Rattan.

Marbled Paper.

Silk Scarf.

Leaves.

Wool Blanket.

Coffee Beans.

Aluminum Foil.

Wood.

Granite.

One of the most versatile uses of your scanner is in producing interesting background effects by scanning objects and textures. You can create your own library of ready-to-use, copyright-free images that can add depth and visual interest to projects that have no photo budget. Often the quality of these images is superior to what you would achieve using a studio camera and lights.

An endless variety of backgrounds is possible—everything from leaves to coffee beans to wood siding can make an appealing backdrop for a catchy headline or block of text. You can also create unique abstract effects by bringing scanned images into an image-editing program where you can posterize them or add a filter.

Fabric and paper textures yield great results. My favorite trick is to scan recycled papers for use in four-color print projects where I want a softer, more textural look on a coated paper.

The key to successful scans is keeping your scanner clean. You don't want kiwifruit juice getting into your scanner's electronic mechanisms! After scanning the great outdoors, take the time to clean your equipment.

In general, backgrounds are best scanned at 100 percent. You should also save them at the same frequency as the intended output. I typically scan at 300 spi, but this level of resolution usually results in a file of at least 20MB for an 8½" x 11" scan! For less detailed imagery, you may be able to make do with a lower resolution, but for highly detailed material, nothing less will do.

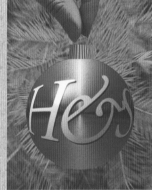

Black-and-White Scan. Final Composite.

Even black-and-white scanners can be used to generate color backgrounds. To make our holiday greeting card, I scanned some pine swags on my black-and-white scanner and then converted the scan to an RGB image in Photoshop. After I changed the overall color to green, I added other holiday images.

Tip

If you're planning to overprint text on a four-color background scan, the scan should be light enough to maintain text legibility. For this reason, it's wise to eliminate the black screen when you convert the scan to CMYK. This increases the contrast of black text overprinting the background and facilitates copy revisions on the black (text) film without affecting the background image.

In Photoshop you can easily create a custom color separation that eliminates the black screen by selecting Preferences/Separation Setup (under the File menu). Choose GCR and set the black replacement to None. Then convert your RGB file to CMY(empty K) and voila, a color separation with no black dot!

Scanning High-Key Images

High-key images are those that have most of the data in the highlight to midtone regions. It's important to note that high-key images are meant to be light, as opposed to an image that is overexposed or faded (see Salvaging a Faded Original on page 82 for more information on restoring a faded photograph). You don't want to "rescue" a high-key image—you just want to make sure it will reproduce at its best.

To achieve optimum results when scanning a high-key original such as this, the objective is to end up with clean whites while still retaining detail in other portions of the image. You may find an initial scan yields a satisfactory high-key image and you may not need to go through the steps outlined in this demo. However, if you need to make adjustments, and your scanning software supports it, you can create a new tone curve and use it to achieve a better image when scanning.

I scanned the image in this demo with no tone corrections and then brought it into Photoshop to determine the optimal tone curve. After saving the revised tone curve and importing it into my scanning software, I was able to rescan this image for optimal data capture.

ORIGINAL
This 35mm slide of an ultra-fair model with lemons is almost as high-key as the classic "polar bear in a blizzard." A histogram of the image verifies this, showing a concentration of data in the highlight regions on the far right portion of the scale.

STEP 1
After bringing the image into Photoshop, you may need to adjust the overall tone of the image. Do this by choosing the Curves command and adjust the RGB channel curve to emphasize the highlights (gamma = 0.75). The curve shown for this particular image increases the contrast in the highlight region, making the midtones slightly darker—just what you want.

STEP 2
In this case, I also selected the red channel of the curve and adjusted it slightly to make the flesh tones warmer. Save the curve to disk and label it High Key Curve or a similar identifier.

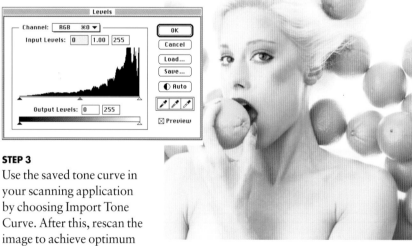

STEP 3
Use the saved tone curve in your scanning application by choosing Import Tone Curve. After this, rescan the image to achieve optimum results. Notice that after the rescan the histogram shows more data in the midtones as well as cleaner whites, indicated by the expanded highlight data in the histogram.

After the rescan, touch-ups can be made in an image-editing program. In this case, I removed dust with the Rubber Stamp tool and the model's eyes were brightened with the Dodge tool.

Tip

When transparencies are scanned on flatbed scanners, light may interplay between the film and the glass platen, producing concentric rainbow-tinged rings called Newton rings in certain areas of your image. (This is why transparency scanners have no glass.) Clean up

the rings on your image by bringing your scan into an image-editing program, or try a re-scan after repositioning the film on a different portion of the platen.

Scanning Low-Key Images

Low-key images are those with most of their data in the shadow to midtone regions. They present a challenge to flatbed scanners, which have a hard time "seeing" the dark regions of an image. The trick is to move some of the data into the midtone regions, while maintaining high contrast in the shadow regions.

The automatic "exposure" feature of most flatbed scanners has a tendency to compensate for the dark regions, resulting in washed-out scans. To get around this problem, I generally scan low-key images with no tone corrections and set Black Point to the darkest region of the image.

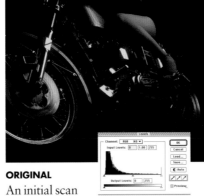

ORIGINAL
An initial scan of this 2¼" transparency shows a concentration of data in the far left portion of its histogram. Notice that very little data was picked up in the midtones and highlights of the image.

Scanning low-key images also tends to produce noise in the shadow regions. To prevent this, I suggest you scan without sharpening your image. Later on, you can select the dark regions of the image and blur them to eliminate noise, then invert the selection and sharpen the remaining midtone and highlight data.

STEP 1
After bringing your initial scan into an image-editing program, adjust the overall tone by using the Curve command and adjusting the RGB channel so the image's data rises dramatically in its shadow regions. This gives you the detail you need in the dark areas of the photo.

STEP 2
In this case, I also selected the red component of the curve and adjusted it to emphasize the flesh tones in the photo. Save the curve by naming it Low Key Curve or a similar identifier.

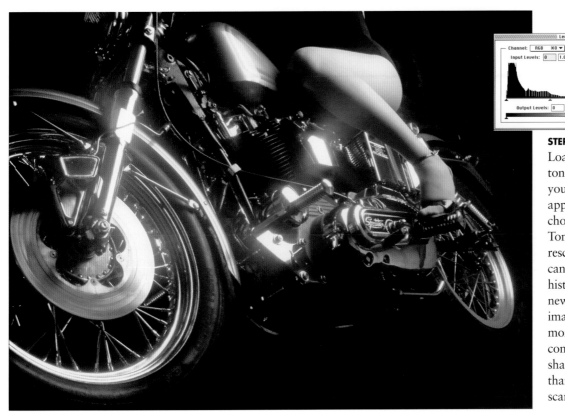

STEP 3
Load the revised tone curve into your scanning application by choosing Import Tone Curve, and rescan. As you can see from the histogram, the new scan of this image retained far more detail and contrast in the shadow regions than the original scan.

Getting the Most From a High-Contrast Original

Ah, the hardest thing to scan is a high-contrast image, unless, of course, the original image is meant to be high contrast. In that case, nothing could be easier!

But I'll assume you've turned to this demo because you have a high-contrast image on your hands that you want to make less contrasty, and that can be tricky.

The problem with a high-contrast original is that all of the data has been squished into the highlight and shadow regions with very little data left in the midtones. The job is to extract as much of the data in the shadow and highlight regions as feasible, and move that data toward the middle while maintaining detail and contrast.

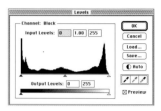

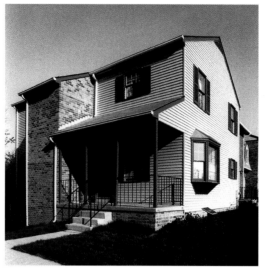

ORIGINAL

This image has highlights that are too light and shadows that are too dark. This photo was printed on high-contrast (#4) photo paper, which contributed to the problem.

A histogram of this high-contrast photo shows that the image's data is bunched at the ends of the tonal spectrum. Adjusting the Levels command won't help because it doesn't allow you to pull the data at both ends toward the middle of the spectrum.

You also might assume that the classic gamma curve is the way to go with a high-contrast original. However, using this curve results in midtones and highlights that lack detail. The only curve that works is an inverted S-curve. With this curve both the shadows and highlights are concentrated toward the midtones—just what you want.

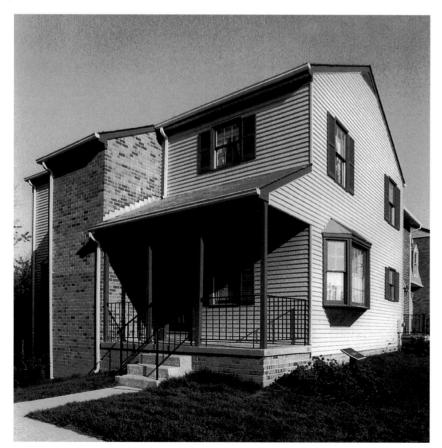

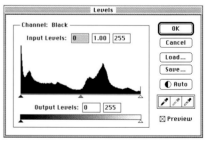

STEP 1

Scanning with an inverted S-curve produces an image that looks less "hot." Pulling up the histogram of this less-contrasty image confirms what the eye can see—a broader tonal range in the midtone region of the image.

Correcting Poor Color

Shooting a picture in poor lighting conditions often results in an image that has an unnatural color cast. But fear not, it's easier to color correct an image in the computer than it is in the darkroom. The surefire way to get outstanding scans every time is to scan first with no tone controls (gamma = 1). Then use the Curves command in an image-editing program to adjust the curves of the image to where the color should be. Save the curve and rescan using Import Curves. You'll get a great image when you scan this time.

STEP 1
I increased contrast in the shadows dramatically by bringing the image into Photoshop and adjusting its curve as shown.

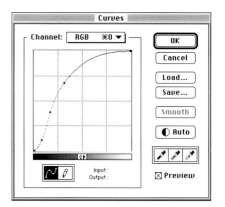

STEP 2
I also added warmth to the picture by separately adjusting the red curve to give it more dominance.

ORIGINAL
This particular image is not only too dark, it's also too blue because it was shot at dusk. The length of the exposure also resulted in reciprocity failure—a consequence of using film not designed to work in low light conditions.

STEP 3
After saving the curve adjustments, I rescanned using the imported curve. A second scan produced this much improved image.

Creating Color Scans From a Black-and-White Scanner

As unreal as it may seem, you *can* make color images from a black-and-white scanner. Although it's somewhat time-consuming and the color isn't quite up to that of a color scanner, the quality will often do in a pinch. Here's how to do it.

You'll need to use three colored filters or gels: pure red, pure green and pure blue (not cyan). These can be purchased at office supply stores (where they're sold for overhead presentations), theatrical supply houses (where they're sold for coloring stage lights), or directly from Eastman Kodak (where they're sold for lots of money).

Green filter scan.

Blue filter scan.

ORIGINAL
The color 4" x 5" transparency used for this demo was scanned at 300 spi for best output to four-color film at a scale of 100 percent. I taped my original to the scanning bed to prevent it from shifting each time I slipped a colored gel between it and the glass. By taping it on just one side, I could easily slip each gel between the original and the bed.

STEP 1
Slide the red gel between the original and the scanning bed. Before scanning, choose Crop and Set White Point/Set Black Point to determine the best exposure. (For this image, I chose the lightest area, the collar label on the second sweater from the right, as set white point and the inside of the shoe as set black point.) Scan the image in grayscale mode and save it as Red Scan, or give it a similar label.

Note: The red gel is likely to be the darkest of the three colored gels, resulting in a noisy scan. You should be able to achieve a reasonable scan in spite of this if your green and blue scans are relatively noise-free.

STEP 2
Repeat this procedure for the green and blue gels, saving each file under a new name.

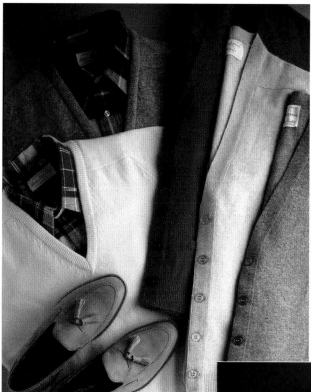

STEP 3

Combine all three grayscale scans into one RGB file by choosing Merge Channels on the Channels dialog box (under the Mode menu). Select Three-file RGB method, choose the file names and click OK. Save as Myscan RGB or a similar name, clean up, and adjust as you would any other.

The color image on the left, created from a black-and-white scanner, pales in comparison with its cousin shown below, a color scan produced from a color flatbed scanner. But as a last resort, it will do.

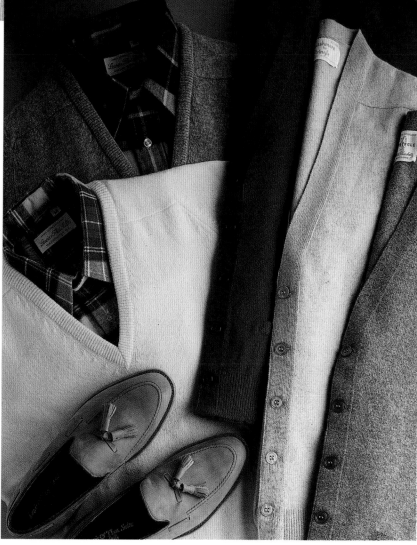

Scanning Color Negatives to Make Color Positives

There's no easy way to create a color positive from a color negative with the scanning software that ships with most of today's flatbed scanners (although slide scanners are another matter). Flatbed scanner manufacturers usually (but not always) provide some tools and support for capturing transparent positives but have sorely neglected the need for information on what adjustments to make when translating a color negative into an accurate color positive.

You'll be in for a shock if you try to create a color positive by scanning a color negative as a transparency and then simply inverting it. The color of the film translates into a color positive that has a sick, bluish cast. This is because when the Invert command is applied to the scanned negative, it converts every color in the image to its complement. Because color negatives are made with an orange substrate and orange maps to blue when inverted, the results are not very appealing, to say the least.

The trick is to bring your negative image into an image-editing program, neutralize the orange cast, "invert" each of the color channels, and save the final curve to use in rescanning, as shown in the following demo.

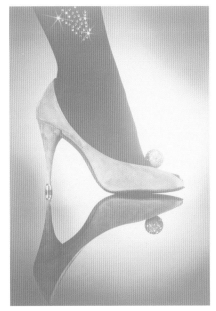

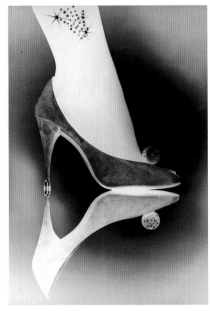

ORIGINAL
The original is a 4" x 5" color negative that was scanned as a transparency at 100 percent and 300 spi. I brought it into Photoshop and adjusted each of the color channels as shown.

WHAT NOT TO DO
Don't use the invert command on a color negative. You'll end up looking awfully blue.

STEP 1
To neutralize the orange color cast before inverting, pull up the Adjust/ Curves/Auto feature that can be found under the Adjust Curves dialog box. Auto forces the overall color in the image to become neutral, removing the orange cast.

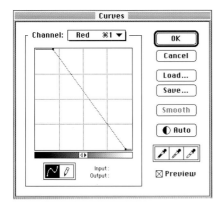

STEP 2

The image left on your screen after applying Auto is still a negative image, but you need to see what you're going to get before you rescan. To see what the positive image will be, and make any necessary adjustments, "invert" each of the color channels. Separately choose each color channel (hidden under the RGB channel menu) and invert each one by dragging the begin/end points to the exact opposite side, and voila, a positive image!

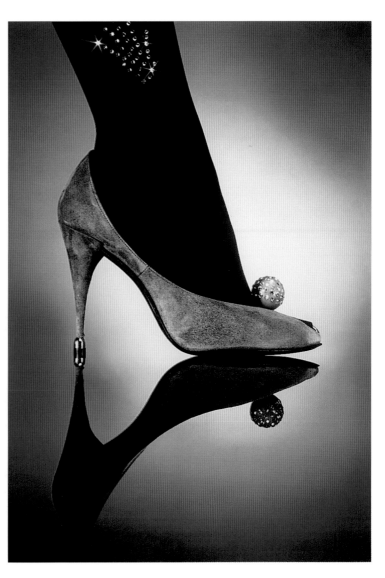

STEP 3

Go back to the RGB channel and make any overall adjustments to the tone of the image. In this case, I wanted darker midtones, so I adjusted the curve downward. If you need to make any individual color adjustments, it's best to go back to the channel in question and make minor adjustments to that particular curve (such as adjusting the red curve to the left for a warmer image).

STEP 4

Save the curve as Color Neg Curve and click OK to exit the Adjust/Curves dialog box. Rescan the image using the imported curve you just saved. You'll get a great "positive" RGB scan that you can then save, clean up and manipulate as you would any scanned image.

Sharpening Scanned Images

The human eye has a natural tendency to view a scanned image as "soft" or out of focus. You'd think that a higher resolution scan would help, but that's not the case. All scanned images need some sharpening, even those scanned on high-end drum scanners. Master printers and color separators will attest to this fact—they've been dealing with this problem for years.

Unsharp masking is the trade term for a standard technique that printers and color separators use to sharpen images by accentuating the differences between adjoining areas of significantly different hue or tone. The traditional technique uses a mask that's a slightly out-of-focus duplicate of the original image. When the original is rescanned with this mask, there is an increase in the degree of contrast at the boundaries of tone shifts, but subtle gradations in tone and hue remain untouched. The result is increased sharpness where you would normally want it—in the most highly detailed areas of the image.

You can apply this same sharpening technique to your images with the Unsharp Mask filter in Photoshop. (Some other image-editing programs offer Unsharp Masking as well.) Here's how.

There are three settings you can choose when you select Photoshop's Unsharp Mask filter:

RADIUS refers to the dimension, in width, of every sample that will be affected by the Unsharp Mask algorithm. I generally choose a setting from 1.0 to 1.5, depending on the resolution of the file and what I've designated for the Amount (described below) and resolution of the file. The higher the resolution of the image, the greater the numerical setting for Radius. The formula to use is output resolution divided by 200. For example, designate a Radius of 1.0 for a 200-spi image. Designate a radius of 1.5 for a 300-spi image. The more Amount you use, the smaller the Radius necessary.

AMOUNT refers to the intensity of the Unsharp Mask effect. A setting from 100 percent to 200 percent will do, depending on the Radius. The bigger the Radius, the less Amount needed. My "standard" Amount setting is 120 percent; however, some images need more than this and others less.

THRESHOLD specifies how many numbers of samples in an image will be sharpened. A setting of 0 affects every sample, whereas a setting of 50 affects almost none of the samples. Highly detailed images, such as line art, require a setting of 3, whereas portraits look best with a setting from 5 to 9. (We want to keep minor wrinkles down to a minimum, don't we?)

It can take a while to come up with the right combination of settings for an image. That's why many manufacturers of scanning software now offer sharpening as an option during image capture.

Tip

Going too far with this technique yields an image that looks obviously fake. It can also produce ghostly "halos" around sharpened areas—a sure sign of too much of a good thing. Apply this technique in moderation.

ORIGINAL

This 35mm slide with no sharpening was scanned at 1,200 spi. The overall image looks slightly (and predictably) fuzzy. The results of several different combinations of Unsharp Mask settings are shown.

Unsharp Mask with Radius 2.0, Amount 200 percent and Threshold 1.

Unsharp Mask with Radius 2.0, Amount 100 percent and Threshold 1.

Unsharp Mask		
Amount: 150 %		OK
Radius: 1.5 pixels		Cancel
Threshold: 5 levels		

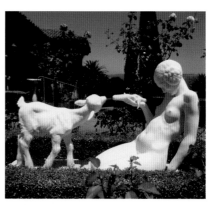

Unsharp Mask with Radius 2.0, Amount 100 percent and Threshold 5.

Unsharp Mask with Radius 1.0, Amount 100 percent and Threshold 5.

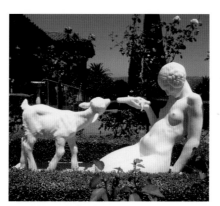

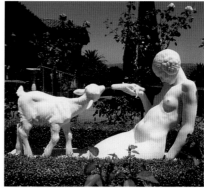

Unsharp Mask with Radius 1.0, Amount 150 percent and Threshold 5.

Unsharp Mask with Radius 1.5, Amount 150 percent and Threshold 5. This setting yielded the best results for output at 150 lpi.

Getting High-Res Backgrounds From Low-Res Data

Let's say you have a low-res scan that you'd like to use for a background. You need to enlarge it to fit your overall image area, but you don't want the pixelated look that results from enlarging low-res images. Well, bunky, the only way to achieve this is to fool the eye. Here's how to do it.

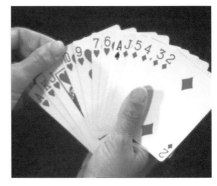

ORIGINAL
This original is a video capture—a 640 x 480 sample grayscale image shot with a black-and-white video camera. It needed to be remade into a slick, print-worthy, four-color image, suitable for display on the cover of a Boston-area magazine.

STEP 1
I captured the video signal using the software that came with my video digitizer. I then saved the image to disk in TIFF format (PICT would have worked just as well).

I opened the saved video-capture file in Photoshop. Because I wanted to add more area to the top of the image, I chose the Image/Canvas command and increased the canvas size from 640 x 480 to 640 x 960, keeping the original data confined to the bottom half of the image area.

STEP 2
I converted the image from grayscale to RGB by choosing the Mode/RGB command and then enlarged it using the Image/Size command. When you enlarge, choose a resolution that is at least the minimum lpi output (for example, 150 spi), and select the proper size width of your final printed image plus allocated bleed for each dimension of at least ⅛ inch. This increases the file size of the image tremendously while the data (and apparent resolution) remains the same. That makes sense—you can't create more data where there wasn't any to begin with!

STEP 3
To fool the eye into perceiving more data than there really is, perform some painterly "magic" on the file by choosing a special effects filter. Aldus's Gallery Effects offers quite a few as does Kai's Power Tools. Some of the special effects filters supplied with Photoshop, such as the motion blur or mosaic, could work as well. For this image I chose a combination of Photoshop's radial blur and noise filters in addition to Fractal Design Painter's oil brush tool.

When the effect is complete, convert the image to a CMYK file, adjust for press conditions and dot gain, and save as a five-file EPS (also known as DCS).

PC Report

October, 1993
Volume 12
Number 10
$2.00

Reviews:
- Netroom 3.0
- Contract Bridge Software

Feature Articles:
- Tracking Your Investments in Detail
- More Installation Adventures

Main Meeting:
Date: Thursday, October 7, 1993:
Topic: Intuit and Symantec

STEP 4 The final touch is to place something in the foreground that the eye will see first and focus on. In this case, the magazine's cover lines and logo served this purpose. The overall effect fools the observer into thinking the background contains more data than there really is. It just goes to prove the old adage: When given a lemon, make lemonade!

Getting High-Res Line Art From Low-Res Data

How do you achieve high-resolution images when you have a low-resolution scanner? You cheat! There are several ways of "cheating" or getting around the low-resolution problem. The best way depends on the type of scanner being used, the scale of your final image, and how detailed your final image needs to be.

The easiest solution, by far, is to scan your image as a grayscale image instead of as line art. The 8-bit depth of a grayscale image gives the illusion of higher resolution, as compared to the 1-bit depth of a line art image.

If you own a low-res scanner, or one that won't support an 8-bit grayscale scan, you can bring the image into an image-editing program such as Photoshop and use the program's editing tools to adjust its resolution, as demonstrated in the procedure on this and the following page.

You can also use a program specifically designed to remove the bitmapped look or "jaggies" that are seen in images produced from low-res data.

ORIGINAL
This 1-bit scan at 300 spi was made from a turn-of-the-century book of printers' and engravers' decorations.

Using Photoshop's Gaussian

STEP 1
Convert your 1-bit line art image into an 8-bit grayscale image by bringing it into Photoshop and selecting Gray Scale from the Mode menu.

Using Ray Dream's JAG II

This is a one-step solution where the scanned image is opened in JAG II and the Anti-Alias command is selected. JAG II does the rest.

Scanning the Original as a

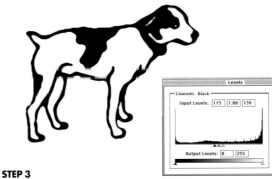

STEP 2
Apply the Gaussian Blur filter, setting the radius at 1.5 to 2.0 pixels.

STEP 3
Open the Levels dialogue box and threshold the data by moving the Hi and Si controls toward the middle as shown. You have to experiment with each image to find out where the settings should be for optimum results.

The final 300-spi image using JAG II.

Scanning our low-res original in grayscale mode produced this 300-spi image.

Salvaging a Faded Original

I suspect this section will be one of the most read of the entire book. And the reason is obvious—there are tons of poor originals out there!

It is my firm conviction that you can obtain better images from poor negatives, prints and slides with your scanner than you can in the best photo darkroom! This is because the computer contains tools that darkroom people can only dream about. I should know—I was a professional studio photographer many years ago.

I will demonstrate how I "rescued" an old picture of my great-grandfather that I found in my parents' attic by adjusting the tonal settings on my Agfa Arcus Plus scanner before scanning, making further tonal adjustments and retouching in Photoshop. Because the final image was reproduced in four-color for this book, it was output directly from QuarkXPress separations as a set of tritone films.

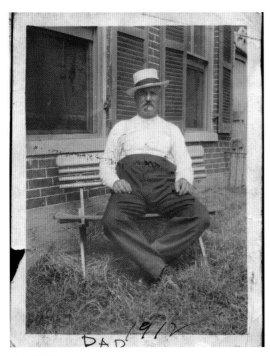

ORIGINAL

Notice how the original black-and-white photo has faded—a classic "sepia" look. This image is a good candidate for a desktop scanner since all the important data is in the midtones. Because this photo is going to be reprinted in a way that replicates its sepia-tone coloring, I will scale it at 100 percent of its original size before scanning. Scanning it at 300 spi gives me the resolution I need for output to a 150-lpi halftone screen at its original size.

It's important to make tonal corrections in a faded original by making adjustments in the lights and darks before you scan, if your scanning software allows this, and after, in an image-editing program such as Photoshop. Your goal is to enhance the tonal range of the original by deepening the shadows and brightening the highlights.

STEP 1

Preview the scan within your scanning software. Set the output levels to add depth to shadows and brighten highlights. Because Agfa's FotoLook drives my scanner, and it doesn't offer a histogram view to show the tonal range of the original, I chose to scan the original with no tone settings and then

look within Photoshop at the histogram (using the Levels command) to see where the data lay. You can see how this faded image has a severely compressed tonal range.

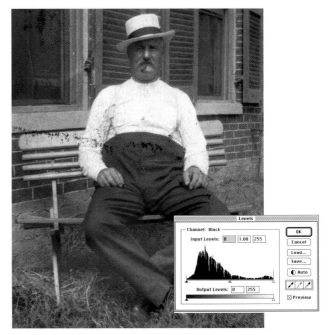

STEP 2

I selected the Dmin/Dmax command on my scanning controls to expand the tonal range of the image. The histogram of the resulting scan shows the results. I also chose to crop the original image since the background contained many stains and smudges and added nothing to the picture.

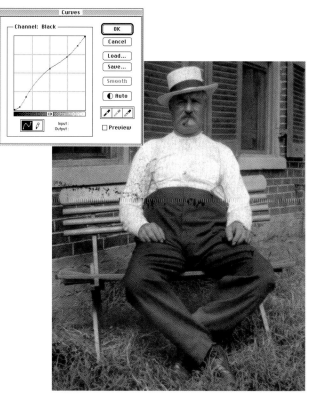

STEP 3

After bringing the scanned image into Photoshop, I made further adjustments in the photo's tonal range by carefully adjusting the Curves control as shown. This adjustment added punch to the shadows and lightened the midtones without affecting the high-lights.

STEP 4

The only way to clean up an image like this is to get your hands dirty! I used the Rubber Stamp tool to carefully eliminate unwanted scratches, dirt and stains. I used the Burn and Dodge tool as necessary for added emphasis. In this instance, the chair, suspenders, hat and eyes were selectively darkened and/or lightened. **Note:** Apple's Photo-Flash software offers automated tools that make quick work of clean-up jobs such as this by eliminating scratches and dust marks. See listing in the appendix.

STEP 5

I chose Duotone from the Image and Mode menus in Photoshop to produce the tri-tone. The curves shown above for magenta, yellow and black yielded the balance I needed for each color. If you don't like the effect produced by the curves you've designated, simply choose Duotone from the mode menu and the dialog box once again appears. Select a new tone curve for each of the colors and you're back in business.

Colorizing an Old Photo

Converting an old black-and-white photo of a family member into a color version of the same photo is something your family will likely cherish (Ted Turner not withstanding). The trick is to colorize the entire photo with warm undertones to add a vintage look, and then individually color different components in the photo.

STEP 1
Bring the grayscale image into an image-editing program and convert to Duotone mode. In this case, I chose a warm reddish-brown as the second color. I adjusted the curves for this color and black as shown. When done, convert the file to RGB mode and save it under a new name.

ORIGINAL
This black-and-white 8" x 10" photo of my dad was scanned at 200 spi as a grayscale image. I brought it into Photoshop to do the colorization.

STEP 3

When using the Paintbrush in Color mode, build up the color slowly by using an opacity of 50 percent or less.

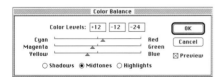

STEP 2

By isolating selected regions (defined by the marquee tool) and using the Paintbrush in Color Mode (instead of Normal), you can add whatever color you wish to your photo wherever you want it. Isolated regions should be feathered with a radius of 2.0 or more when they're selected to soften their edges.

STEP 4

Individual regions can also be colorized by choosing Balance Colors, under the Image menu and Adjust submenu, and sliding the adjustments to the left (for more saturation) or right (for less) until the desired color is achieved.

When colorizing an old photo, choose subtle colors for a realistic, timeworn look. Use a brighter, more vibrant palette for a postcardlike effect.

Scanning Fine Line Art

This highly detailed lithograph by Charles Dana Gibson can be reproduced in a variety of ways, depending on how much detail can be sacrificed for a smaller file size.

A lot depends on output. Printing it on a 300-dpi laser printer requires a less detailed image than output to film or an imagesetter. When the image goes to press, printing it on an uncoated paper requires less definition than printing it on a coated paper. A smaller image requires less definition than one that runs full page.

To hold the fine lines of this etching, one option is to scan the line art as a grayscale image. In fact, anyone with a low-resolution scanner almost always gets a better scan with grayscale than with line art mode. Why? Because resolution is affected by bit depth. The greater the bit depth, the greater the apparent resolution. This means that grayscale images, with a depth of 8 bits, always appear to have higher resolution than a 1-bit line art image. A 300-spi grayscale scan of an image should show as much detail as a 600-spi line art scan of the same image. Although the grayscale image has a lower resolution than the line art image, it has a larger file size than the line art image.

Grayscale images have other advantages over images scanned as line art. They can be manipulated and rotated more easily, and are not bound by sizing considerations like a bitmapped line art image is. Bitmapped scans can only be scaled in a page layout program by a mathematical proportion of the output frequency. Typical output resolutions of imagesetters are 1,200, 2,400 and 3,600 dpi. Thus, a 120-spi, 1-bit image imported into a page layout program should be scaled at 50 percent, 100 percent, 200 percent, 500 percent or 1,000 percent for optimal results when

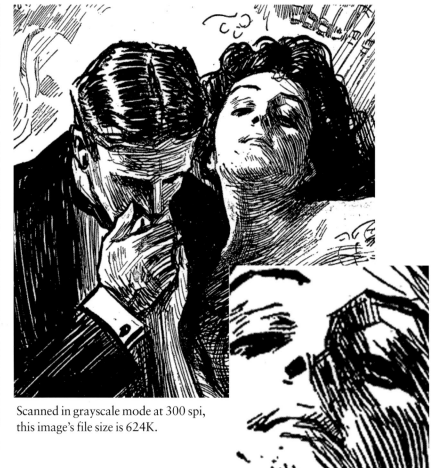

Scanned in grayscale mode at 300 spi, this image's file size is 624K.

Scanned in bitmap or line art mode at 300 spi, this image's file size is 96K.

printed on a 2,400-dpi imagesetter.

The downside to using grayscale images is that they need to be halftoned at print time at typical print resolutions of 150 to 200 lpi. As a result, some types of line art images, particularly those with precise detail, may look slightly fuzzy. Line art with regular patterns may also create moirés when halftoning.

Scanning an image in line art mode may be the most appropriate choice if you're pressed for time, simply because it's usually faster to scan at this setting. Most scanners return a line art image in about half the time required for a grayscale image. This can be an important consideration if you're scanning many images at one setting.

If your scanner supports high resolution scans, scanning at the resolution of your imagesetter's output (1,200 or even 2,400 dpi) creates the sharpest looking output

you can possibly get. 2,400-spi scans are serious stuff, but boy do they ever look good! This type of scan is used by professional publishers for high-quality art books. Remember, you can achieve an effective 2,400 spi with a 600-spi scanner simply by reducing your scan to 25 percent.

To summarize: Use grayscale for low-resolution scans of line art. For higher resolutions, 1-bit mode is best. Consult the table below:

Recommended Settings for Line Art Scanning

SCANNER MAX SPI	IMAGESETTER DPI	SUGGESTED SCAN MODE	SUGGESTED LINESCREEN
300	300	1-bit	
600	300	not recommended because of oversampling	
300	600	1-bit	
600	600	1-bit	
300	1,200	grayscale	133
600	1,200	1-bit	
1,200	1,200	1-bit	
300	2,400	grayscale	150
600	2,400	grayscale	150
1,200	2,400	1-bit	

Scanned in line art or bitmap mode at 600 spi, this image's file size is 324K.

Scanned in grayscale mode at 600 spi, this image's file size is 424K.

Scanning Borders and Frames

CONVERSION USING PHOTOSHOP

Scanning solid black artwork to be used as a border or frame requires little other than proper alignment so that corners, vertical lines and horizontal lines are all square.

However, scanning borders that have been previously reproduced requires clean-up and conversion to suitable electronic artwork. This can be done easily with an image-editing program such as Photoshop. The final border art can then be made more workable by converting it to line art with a program such as Adobe Streamline, which converts bit-mapped artwork into editable line art.

ORIGINAL

This original print came from a turn-of-the-century specifier catalog of compositors' borders and decorations. Notice in this initial scan how the paper has yellowed and the colors are muted. If your software supports it, you can eliminate the yellowed background when scanning by mapping the background color to pure white with Set White Point.

STEP 1

Bring the scan into an image-editing program. In this case, I used Photoshop. By selecting the background with the Magic Wand tool, you can isolate it from the border and create a mask.

STEP 2

Create a pure white background by selecting the mask and filling it with pure white. Save this as an RGB file. For many purposes, this scan would do just fine as is, but because I wanted a "spot" color version for use in a design I was creating in PageMaker, I took this version of the border through additional steps as depicted.

#2 Red Channel

#2 Green Channel

#2 Blue Channel

STEP 3

I created an electronic mechanical or spot color version of the border by using the channel calculation commands under the Image menu. In this case I (a) duplicated the red channel, (b) calculated the difference between the red and green channels and inverted the results to obtain the red berries, and (c) duplicated the green channel and moved it into the blue channel.

Calculate/
Duplicate

#3 Red Channel

Calculate/
Difference
and invert

#3 Green Channel

Calculate/
Duplicate

#3 Blue Channel

STEP 4

Because I wanted a mechanical comprised of solid art, I used the Levels command to eliminate any "grayness" in the final border.

Conversion Using Adobe Streamline

This is a Streamline version of the border created in Step 2.

The Streamline version shown here was made from the final electronic mechanical shown in Step 4.

The electronic mechanical created with Photoshop works, but it's an incredibly large file, weighing in at 4.2MB—and that's just half of a complete border!

Adobe Streamline converts color images into line art, resulting in a smaller file size, which in turn means faster printing and more flexibility when incorporating your scanned border into other art.

Using Streamline couldn't be easier. Import the image into the program, set a few controls to tell Streamline what kind of conversion you want (outline or inline, color or black and white, tight or loose tolerance, etc.). In a short time you have Adobe Illustrator compatible line art. Save the file to disk and you're done.

Scanning Postal Codes and Signatures

An electronic file of postal codes can be a real time-saver for desktop publishers wanting to imprint their envelopes and postcards with this information. The U.S. Postal Service makes it relatively easy for you to acquire the art you need as your original for scanning.

First, apply for a business reply mail (BRM) or business reply card (BRC) permit from the USPS. A few business days later, you will receive a printout or hard copy original with the Facing Identification Mark (FIM) and the POSTNET bar code for your particular ZIP code as well as the postage indicia or permit imprint that goes where the stamp is normally affixed.

Before the days of desktop publishing, this printout was pasted down as a traditional mechanical that was then taken to a printer for printing. However, you can use your scanner to incorporate this artwork into as many electronic mechanicals as you wish. The trick is to be sure your scan is perfectly square and that there is no variation in the width of the bars.

You'll want to scan these items as a single piece of artwork, just as the USPS furnishes them, with the alignment guides intact. Although this results in a larger file, it aids greatly in the placement of your scan in a page layout program.

Scan these regions from the Post Office art in their entirety (as shown) to assist with accurate placement in your mechanicals

BAR CODES

For artwork such as this, where accuracy and crispness are of prime importance, high-resolution 1-bit scanning in line art mode works best. Grayscale scans tend to be too fuzzy. Scan at a resolution of 600 spi or higher to capture the artwork. You may have to rescan and adjust the original several times to be sure the artwork is perfectly square. (Ofoto users have an advantage because their software has a feature that automatically straightens images.)

Whether it's a postcard or an envelope, I suggest you take a laser print of the final artwork to your local U.S. Post Office and have them OK the layout. They should be able to test the bar codes and FIM on their equipment to make sure they can be accurately read.

Tip

I suggest you avoid using previously printed artwork as an original. You can pick up debris and texture from the paper when you scan, necessitating post-scan clean-up. The printing process also may have resulted in smeared ink or distortions such as shearing the angle of the bar code or FIM.

You're also taking a chance of not meeting postal regulations when you copy a non-USPS original—possibly an illegitimate one. It's just not worth taking a chance—get a USPS-approved original.

Signatures

If you send a lot of faxes, having your signature on hand to place into your documents can be a real time-saver. Scan your signature at an spi that is a multiple of your output device. For instance, if your fax machine outputs images at 200 dpi, you want to scan your signature at 200 spi. Save it as a TIFF file, and it's ready to import into a page layout or word processing program.

Using a Polaroid Camera With a Scanner

If you're in a pinch for a quick image, Polaroid offers an instant solution. Take a picture of your subject with a Polaroid camera, scan the picture into your computer and voila—you've captured your image! Polaroid's new professional Polacolor PRO 100 instant print film is extremely accurate and provides highly detailed results. However, be careful when using Polaroid black-and-white instant film—it requires a special liquid coating to prevent the image from deteriorating. Give this coating plenty of time to dry before you put the image down on the glass platen—it's very sticky and hard to remove!

For more information on tone correcting, see chapter one, page 9.

ORIGINAL
Take your picture, remembering to keep the exposure even, the camera steady and subject(s) in focus. Compose the subject matter to completely fill the image area of the film to minimize the need for cropping when you scan. This particular print was made using Polacolor type 59 instant print film, a standard for "everyday" use with a 4" x 5" camera. After making sure your print is completely dry, place it on the glass platen of your scanner.

Scan at 300 spi at 100 percent—about the maximum resolution limit of Polacolor instant print film. This 200 percent enlargement of my original 1:1 scan shows that the detail available in a Polacolor print is quite good. I have even used Polacolor prints for full-bleed 8½" x 11" backgrounds!

If necessary, bring the completed scan into an image-editing program and tone correct as you would for any other scanned image.

Creating Custom Computer Screens

CREATING A MACINTOSH STARTUP SCREEN

Everyone likes to customize their computer. Especially if it doesn't cost anything! Nothing could be easier. Follow these instructions to create a custom screen that will appear every time you start up your Macintosh. A bonus is that this method doesn't use up any precious system memory since a startup screen is flushed from memory once the system boots.

Scan your original to exact screen size or larger than intended screen size (see table in Step 1 below).

Nearly any kind of original will do since the computer's screen resolution is significantly smaller than what is typically used for print. For my startup screen I used a 4" x 5" snapshot of my daughter with her cousin. I scanned it in at 300 spi and scaled it to cover an area of 1,200 x 1,500 pixels—big enough to fill even the largest computer screen. Once you've scanned your image, clean up and color correct in an image-editing program, if necessary.

Macintosh 12" Display	512 x 384 pixels
Macintosh 13" & 14" Display	640 x 480 pixels
Macintosh 17" Display	832 x 624 pixels
Macintosh 20" Display	1024 x 768 pixels

STEP 1

Crop and resize in Photoshop to achieve the correct pixel dimensions. Use these measurements for standard display monitors with 8-bit color.

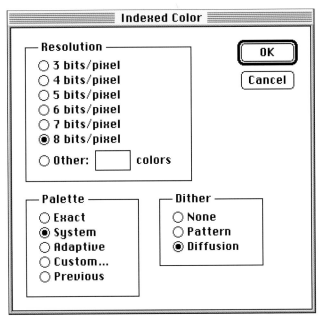

STEP 2

Convert to Index Color Mode/8-Bit System Palette with dither. Then choose the Save As command from the File menu.

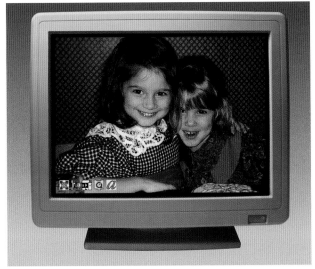

STEP 3

Name the file "StartupScreen" and choose PICT Resource as the File Format. Save the file StartupScreen in your system folder, and that's it! The next time you boot your machine, you will see the startup screen image displayed. Most people are impressed when they see a picture of your loved ones lighting up the screen at startup. Needless to say, it can remind you what's really important in life.

CREATING A MACINTOSH COMPUTER SCREEN BACKGROUND

It's easy to create a custom background screen for your Macintosh. But before you begin, you'll need to purchase a control panel/INIT such as DeskPicture from Now Utilities to load the background onto your computer. Once that's taken care of the rest is simple.

I used the same photograph of my daughter and her cousin to create a custom background screen for my Macintosh in the following demo.

STEP 1
Before you begin, take note of the amount of memory a background screen will take up in your system folder. Here's the amount of memory required for the following screen sizes:

Macintosh 12" Display	196k
Macintosh 13" & 14" Display	307k
Macintosh 17" Display	519k
Macintosh 20" Display	786k

STEP 2
Follow Steps 1 and 2 for Creating a Macintosh Startup Screen, except when sizing for your screen, subtract 20 pixels from the height of the image to allow room for the Macintosh menu bar and save the image as a PICT file instead of PICT Resource. Name this file anything you want, but be sure to check your application to see if special names are required.

Install and launch the control panel/INIT to load the picture into memory. Reboot your Mac to see your new background.

CREATING A WINDOWS 3.1 SCREEN BACKGROUND

The same kind of custom background screen can easily be achieved on a PC. You need to scan the original to exact size or larger than the intended screen size and color correct as necessary in an image-editing program as described in the Macintosh version of creating a startup screen. This method does take up some system memory, so take heed.

13" VGA Display	640 x 480 pixels	307k
16" Super VGA Display	800 x 600 pixels	480k
19" Super VGA Display	1024 x 768 pixels	786k

STEP 1
If your screen background image is too large to fit on screen or if it doesn't fit in memory, Windows won't load it. Check this chart showing the amount of system memory required to handle an 8-bit color image to be sure your PC can handle the image you want to load on your screen.

STEP 2
Crop and resize in Photoshop to achieve correct pixel dimensions for your particular screen. Convert to Index Color Mode/8-Bit System Palette with dither. Choose the Save As command from the File menu and name this file Myfile.BMP or any other legal DOS name. Choose File Format: BMP and save in the C:\Windows subdirectory.

STEP 3
Open the Control Panel in the main program group and choose the Desktop icon.

STEP 4
Select your BMP file from the Wallpaper File list box and check Center. Reboot Windows to see your screen background.

CHAPTER FOUR

Gallery Section

Introduction

Most of us in the graphic arts rely on our studio scanners for bringing all kinds of visuals into the publications and promotions we produce. Scanners have become our studio workhorses, saving time and money by replacing conventional photostats, separations and halftones which would have otherwise been produced by outside vendors. Our scanners are in constant use, capturing photos, illustrations, logos and other graphic elements. However, we rarely take the time to fully explore our scanner's capacity for more creative applications.

Some of our more adventurous colleagues, however, have been experimenting with scanners as an artistic medium, developing innovative techniques that go far beyond the traditional pre-press graphics and image digitizing most of us do. These creative professionals are using their scanners to produce exciting visual effects not possible with conventional photography or prepress technology.

Some are using scanners to salvage treasured photographs, restoring them to gallery-worthy status with state-of-the-art hardware and their own custom software. Others have found they can use their scanner much like a studio camera, capturing models and other subjects with dramatic results that exceed the capability of traditional photographic methods. Even more are experimenting with collage effects, achieving a sense of incredible depth and realism by scanning arrangements of objects placed directly on the scanning bed. Each of these individuals has interjected his or her own artistic vision into the scanning process to produce a variety of exciting results.

This chapter features the work of these creative professionals and shows how state-of-the-art scanning technology has been fully exploited in the development of some of the most unique imagery to be seen in years. We've chosen to focus on eight creative teams and individuals who have elevated scanning to an artform, producing outstanding work which has received recognition from both the design and fine arts communities. Much of it has won awards, been featured in design annuals, or even appeared in museum collections.

These individuals have explored and refined their scanning methods through trial and error and countless hours of experimentation. They will share some of their techniques and scanning tips with you in this chapter. I am pleased to showcase their work in this section as well as the story behind each piece featured in the hope that you will be as amazed and inspired as I am by the creative potential inherent in scanning as a new artistic medium.

Evans Day Design

Situated in the old seaport of Newburyport, Massachusetts, Evans Day Design specializes in the design and production of books, postcards and posters. Among the firm's many clients are Addison Wesley, Northeastern University Press, Random House and IBM. Partner Rob Day is author of *Designer Photoshop* by Random House. In addition to his own book, his work has been featured in many other publications including *Step-by-Step Graphics*, *Print* and *Communication Arts* magazines.

Day never aspired to be a "scanmeister." He was trained in fine arts with a major in printmaking. However, when he joined forces with nationally known designer/illustrator Lance Hidy in 1988, he began experimenting with the flatbed scanner, using it to capture a variety of 3-D objects.

When Day was commissioned to produce the illustrations for *Walt Whitman,* a biography by Nancy Loewen, he was able to draw upon his experience in 3-D scanning. Because the book focuses on Whitman's seminal work *Leaves of Grass,* the book's art director, Rita Marshall, chose leaves as a visual theme. Day decided to use the scanner to collect the bulk of the leaf imagery. His 35mm camera was also used to collect other images of leaves to "round out" his selection of imagery.

Day used a Microtek MSF-300z flatbed scanner and Nikon LS-3500 slide scanner to capture his leaf images

"EXPERIMENTING WITH THE EQUIPMENT OVER THE YEARS HAS REALLY PAID OFF. BY SETTING UP MY STUDIO WITH A COLOR CALIBRATED MONITOR, CONSTANT AMBIENT LIGHTING, AND A 5,000K VIEWING BOOTH BEHIND MY MONITOR, I AM ABLE TO GET TOP-QUALITY COLOR USING ORDINARY HARDWARE AND SOFTWARE."

and archived them onto a 650MB MO drive. Photoshop was used to color correct and separate the scans using customized output tables.

Photographs of individual leaves captured on 35mm film were scanned on the Nikon LS-3500 at 2,000 x 3,000 samples. The leaves were placed directly on the Microtek flatbed and scanned at 300 spi. Most images were rescaled in Photoshop to maintain 225 spi at 100 percent final size. Day prefers to scan using the default settings of his scanners—he doesn't trust their interpolation algorithms as much as he does Photoshop's. Shadows were created using a variety of masking techniques. Final color correction, unsharp masking and separations were done in Photoshop.

The key to the quality of this piece, and the others produced for the book, was the ability to use an actual press proof as a scanning target. Rob used the Olé No Moiré CMYK image supplied with Photoshop to create films that were then sent to the printer for press proofs. These came back and were immediately used to visually correct the Olé No Moiré image on screen using Photoshop's Printing Setup controls. Once set, the saved calibration was used to generate all the RGB-to-CMYK conversions of leaf scans for this particular press. The result was near perfection.

This gorgeously printed and designed book was published in 1993, by Creative Education, Mankato, Minnesota. It is one in a series of *Voices in Poetry*.

*N*ot to exclude or demarcate, or pick out evils
from their formidable masses (even to
expose them,)
But add, fuse, complete, extend—and celebrate the
immortal and the good.

Haughty this song, its words and scope,
To span vast realms of space and time,
Evolution—the cumulative—growths and generations.

Begun in ripen'd youth and steadily pursued,
Wandering, peering, dallying with all—war, peace, day
and night absorbing,
Never even for one brief hour abandoning my task,
I end it here in sickness, poverty, and old age.

I sing of life, yet mind me well of death:
To-day shadowy Death dogs my steps, my seated
shape, and has for years—
Draws sometimes close to me, as face to face.

From "Second Annex: Good-bye My Fancy"
Leaves of Grass

W A L T.
WHITMAN

TEXT BY
NANCY LOEWEN

*T*his is what you shall do: Love the earth and sun
and the animals, despise riches, give alms to every one
that asks, stand up for the stupid and crazy, devote your
income and labor to others, hate tyrants, argue not con-
cerning God, have patience and indulgence toward the
people, take off your hat to nothing known or unknown
or to any man or number of men, go freely with power-
ful uneducated persons and with the young and with the
mothers of families, read these leaves in the open air
every season of every year of your life, re-examine all
you have been told at school or church or in any book,
dismiss whatever insults your own soul, and your very
flesh shall be a great poem and have the richest fluency
not only in its words but in the silent lines of its lips and
face and between the lashes of your eyes and in every
motion and joint of your body.

From the preface
to the 1855 edition of
Leaves of Grass

ArtScans

Davis Coons is a color specialist who, with his wife Susan, runs a large-format scanning service for computer and fine artists. ArtScans offers true four-color reproduction through direct digitization of large-scale art on a custom-built scanner for which they wrote the software. Many fine artists prefer their scanner over conventional, high-end drum scanners for its purity—it eliminates the need to scan from a transparency of the art.

Based just outside Los Angeles, in Manhattan Beach, California, Coons also does monitor calibration and writes custom scanning software for various area clients. In addition to understanding color and knowing how to program computers for accurate color reproduction, Coons has a great appreciation of art and photography and enjoys the challenge of faithfully reproducing fine art.

He was first introduced to photographer/musician Graham Nash (of Crosby, Stills and Nash) in 1989 by a mutual friend, Steve Boulter, of Iris Graphics, Inc. Nash had accumulated a library of stunning photographs of fellow musicians over the course of his remarkable career. When he learned of Coons's extensive knowledge in four-color reproduction, Nash supported him in the resurrection of a number of these prints. Among the prints Nash and Coons worked to make gallery-worthy was a portrait of David Crosby taken early in the musician's career. Nash had a 2" x 2½" contact sheet proof of the portrait, but nothing else to work with—the negative and original print were long since gone.

In addition to scanning the Crosby image as a sub-

"IF YOU'RE GOING FROM REFLECTIVE ART TO PRINT, ELIMINATING THE INTERMEDIATE STEPS THROUGH DIRECT DIGITIZATION WILL GIVE YOU THE MOST ACCURATE RESULTS."

stantial, one-step enlargement, Coons needed to retain detail and richness in the midtones and shadows of the portrait. Coons did a number of experimental scans, working on several flatbed scanners and using off-the-shelf software, but he decided that the job warranted the development of a custom application. Working on a NeXT computer, which has a UNIX-based platform, Coons developed a remarkable program that utilizes all four color in the reproduction of black-and-white prints. The highlights and lighter midtones of the Crosby portrait are all composed of black. However, when the midtones reach the point where the grays are 50 percent black, the remaining inks (cyan, magenta and yellow) are gradually eased in to add richness to the darker grays of the shadow regions. The solid black areas are comprised of a 100 percent saturation of all four colors.

The Crosby scan was reproduced by making an Iris print on 100 percent rag, Arches cold-press watercolor paper. The rich texture and deckled edge of the paper adds to the portrait's sense of depth and intimacy.

Coons and his wife now work jointly with Nash Editions, a fine art digital print-making studio founded by Graham Nash that specializes in producing high-quality Iris prints. Nash Editions relies on ArtScans's custom-built scanner, located two doors away, for the digitization of much of their work. In addition to scanning for output to Iris prints, ArtScans also creates accurate color separations for offset presses.

Schlowsky Computer Imagery

Schlowsky Computer Imagery is located in the bucolic woods west of Boston. The husband-and-wife team's combined backgrounds in traditional photography and illustration give them a knack for combining true artistry with the latest digital tools in the production of jobs for such internationally known clients as Scitex, Leaf, Kodak and Radius.

Most of the Schlowskys' work is digitally based; however, Bob Schlowsky continues to use his 35mm camera to acquire material for the couple's library of imagery. Recently, he and Lois were spotted in the Utah Rockies capturing future digital fodder. Stock slides are the backbone of the team's dreamlike digital photo illustrations.

When D.C. Heath commissioned the Schlowskys to produce an illustration for a story about a Laotian high school student about to take a driving test in the United States, the couple had to do some research to come up with the imagery they needed for a suitable photo montage. They were able to find a book in the Weston, Massachusetts, public library from which they could scan Laotian text. Images of a stop sign and automobile were easier to acquire. Bob shot them with his Nikon. Other images, such as an orchid, and various tex-

tures were available digitally from the archived images the Schlowskys have accumulated over time. Lois used HiRes QFX software from Ron Scott Inc. on a PC clone to combine all the images into the final montage.

The Schlowskys scanned their images on a Leafscan 45 transparency scanner and a Leaf Digital Camera Back attached to a Hasselblad body. Before the images were assembled into a montage, they were brought into Photoshop, running on a Macintosh 950, where unsharp masking was applied. Individual scans were captured at 3,000 x 4,000 samples (for the Leafscan 45) and 2,000 x 2,000 samples on the Leaf Digital Back. All images were scanned at a resolution to maintain at least 225 spi when scaled to 100 percent to 150 percent of their final size.

Proofs were made using a Kodak XL7700 digital proofer. Final film for offset printing was generated electronically from supplied five-file EPS separations created in Photoshop and output at a color service bureau on an Agfa SelectSet 5000 imagesetter at 2,400 dpi and 150 lpi. Software, scanner, monitor and proofer were all painstakingly calibrated using Bob's proprietary lookup tables.

> "CALIBRATING YOUR SYSTEM IS THE MOST IMPORTANT, AND ONE OF THE MOST PAINSTAKING, THINGS YOU MUST DO IF YOU WANT TO BE SERIOUS ABOUT DIGITAL IMAGERY."

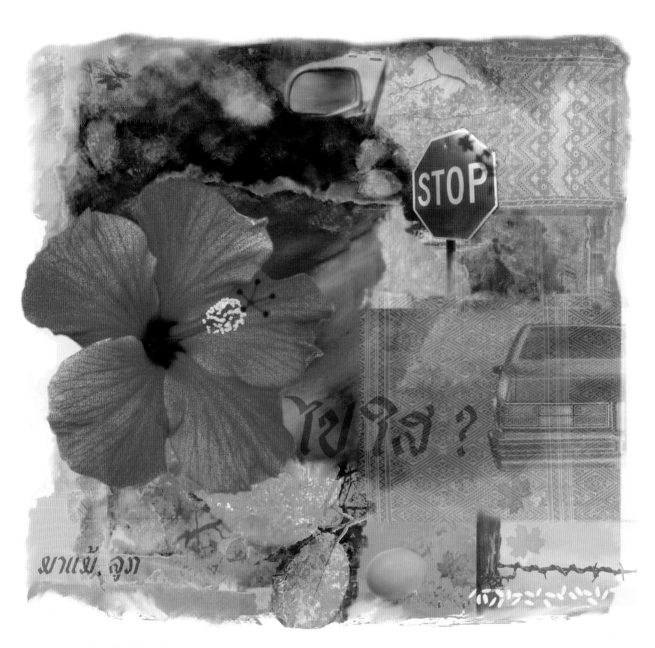

© 1994 Lois and Bob Schlowsky

Imaging Solutions

Imaging Solutions is a consulting firm specializing in digital photography and electronic imaging. Over the years the firm has helped many photographers and designers explore the advantages of leveraging new technology such as digital cameras and scanners.

Practicing what he preaches, owner Jonathan Reff has experimented with pushing the envelope of technology. His background in fine art photography allowed him to envision the scanner as a large portrait camera, akin to the large-format studio cameras of one hundred years ago. By mounting the scanner vertically and removing the cover, he created the equivalent of a 300-spi 8½" x 11" studio camera—albeit a slow one and with little depth of field, but one capable of producing dramatic results.

Inspired by this discovery, Reff has endeavored to create a series of artistic work-in-progress portraits. By placing a model in front of the scanner "camera" and lighting the subject with tungsten studio lights, he's been able to achieve a unique "soft focus" effect—remarkably similar to the style of portraiture achieved by photographers of the last century.

The only downside to his technique is that his models have to sit perfectly still for about a full minute while the scanner makes its pass. Yet it is this stiff "posing" and soft-focus effect that give Reff's images such a unique quality.

To produce his unique portraits, Reff uses a Tamarack 600c scanner equipped with Photoshop and a Tamarack-supplied scanner plug-in. Final output for each of his images is a 22" x 26" Iris Ink Jet print, provided by Nash Editions of Manhattan Beach, California.

"I RATHER LIKE THE NON-HIGH-TECH LOOK OF THESE PORTRAITS. AS THIS IS A WORK IN PROGRESS, I AM CONTINUALLY EXPERIMENTING WITH DIFFERENT SETTINGS, DIFFERENT SUBJECTS. WHILE USING THE SCANNER AS AN ARTISTIC TOOL WAS SERENDIPITOUS, I WOULD HOPE OTHERS WOULD USE THEIR OWN EQUIPMENT IN ARTISTIC WAYS YET TO BE DISCOVERED."

ALAN BROWN
Photonics Graphics

Alan Brown is president of Photonics Graphics, a Cincinnati-based firm specializing in electronic illustration and photography. Originally a commercial photographer, Brown first got involved in working with Photoshop when his photography studio was tapped as a test site for the beta version of the program. He gradually expanded his computer expertise and business to incorporate an increasing amount of electronic work. Brown's studio now consists of a staff of seven. His work has won numerous awards and has been featured widely in *HOW, Print* and *Step-by-Step Graphics*.

When Brown was commissioned to develop photo collages as illustrations for Huffy Corporation's 1993 annual report, he was asked to come up with a cover rendering as well as illustrations to represent each of the corporation's six businesses. Each business required a full-page collage incorporating a variety of objects that represented the products and services of that enterprise.

Brown used a combination of images scanned on Photo CD, flatbed scans, and illustrations created in Strata StudioPro and Adobe Illustrator to come up with images for the annual report's cover and the other six collage illustrations. He used Adobe Photoshop to adjust the tone and overall quality of the scanned images, and then assembled the images into a final illustration with Specular International's Collage, a program that allowed him to scale and position all of the illustration's various components.

The completed collage illustrations were brought into Photoshop where other refinements were made and then imported into Aldus PageMaker where type was added and the final illustrations were converted to CMYK files for output to film.

Brown relied on Photo CD scans for incorporating many of his photographic images into the collages. For example, the doll, high chair, and man with a child in an infant carrier were all Photo CD scans. Brown used an 11" x 17" Howtek flatbed scanner equipped with Photoshop plug-in software to scan the line art of the baby and infant carrier as well as the childlike drawings, commissioned by Brown from his seven-year-old son. (Brown says his son was paid for his work—five dollars for the original sketches and a round of revisions.) The soft pastel background was created from scanned fabric, softened with the aid of Photoshop.

"YOUR COMPUTER AND SCANNER ARE ONLY AS GOOD AS THEIR CALIBRATION. RUN A TEST ON A SCANNED IMAGE BY TAKING IT ALL THE WAY TO FINAL FILM. COMPARE THE MATCHPRINT MADE FROM THE FILMS TO THE ORIGINAL TO BE ABSOLUTELY SURE WHAT YOU'VE SCANNED IS WHAT YOU'LL GET."

HUFFY CORPORATION 1993 ANNUAL REPORT

Past - Present - Future

GERRY BABY PRODUCTS COMPANY

Re:Design, Inc.

Ron Meckler, former art director of *MacUser* and *Wet* magazines, has followed his own path since 1986. Today his award-winning design firm, Re:Design, employs a staff of five. Based in lower Manhattan, the firm's clients include the *New York Times,* Ziff Davis, *Spy* magazine and Charisma Records.

Re:Design is a computerphile's dream. This small but talented team uses every conceivable piece of software as well as three flatbed scanners and one slide scanner on a daily basis. Nearly every project makes use of digital scans at some point in its design cycle. For about 25 percent of their projects, Meckler sends out for high-end drum scanning—which means that 75 percent of Re:Design's projects use "ordinary" scans as final art. But ordinary is no way to describe Re:Design's portfolio.

A case in point is a recent illustration commissioned by art director Wendy Bass at Macmillan—a cover for a book to be entitled *Black Magic* on how Steven Jobs, founder of Apple Computers, was literally "burning" money on his way to fame and infamy. Meckler knew he could put together a "hot" cover by scanning some left-over stock photography from his files.

Meckler set about creating a composition in Photoshop that would include flames, a $100 bill, and an image of Jobs. He already had a transparency of flames, left over from a photo shoot from a previous job, that he scanned on a Microtek 35mm slide scanner. The $100 bill was scanned directly on the studio's AVR 8000/CLX flatbed scanner.

Because Meckler was producing a low-resolution comp, as opposed to outputting final films for print, all images were scanned at 150 spi. Output for the presentation to the art director was via a Tektronix Phaser III at 60 lpi and 300 dpi.

"SCANNING IS REAL-WORLD IMAGERY'S GATEWAY INTO THE ELECTRONIC REALM."

The project was on schedule and on budget and the art director loved the cover concept. But while Meckler labored over his comp, Macmillan decided to change the name of the book to *Steve Jobs and the NeXT Big Thing*—not exactly the incendiary cover title Meckler had been working to illustrate.

Nonetheless, Meckler completed the re:assignment, and produced an entirely different concept.

BLACK MAGIC

STEVE JOBS & THE NEXT BIG THING

RANDALL STROSS

Darryl Curran

Darryl Curran is chairman of the art department and teaches photography at California State University Fullerton. He has worked with photographic imagery and light-sensitive processes for the past thirty years, and recently expanded into using the scanner as a "camera" to capture images for photomontages.

Unlike most computer artists, who scan images and then arrange them within an image-editing program, Curran's photomontages are composed directly on the scanning bed. His prints have an unusual sense of depth and are quickly gaining recognition in the fine arts community. In fact, several are now in the collection of the Los Angeles County Museum of Art.

A self-confessed "pack rat," Curran starts a photomontage by bringing boxes of found items to Nash Editions, a Southern California-based fine art and digital printmaker. Curran rents time on the studio's Agfa Arcus scanner which runs on FotoLook, an Agfa plug-in for Photoshop.

Curran's collection of objects ranges from scraps of fabric to garden tools. He arranges them directly on the scanning bed, layering objects so that the first items on the bed are in the foreground. Curran prefers to work

"THE SCANNER IS SIMILAR TO A PINHOLE CAMERA. IT'S PERCEIVED AS HAVING LIMITED ABILITIES. ONE SIMPLY HAS TO ACCEPT THE LIMITATIONS AND EXPLOIT THE SCANNER'S UNTAPPED POTENTIAL."

this way because the scanner's illumination provides a unique sense of depth, unobtainable through arranging individually scanned objects. Objects in the foreground have a remarkable degree of detail, while those in the background appear soft and dark, eventually fading away into oblivion.

Curran usually spends about two to three hours producing anywhere from two to six photomontages, working with Mac Holbert, co-founder and operations manager of Nash Editions, and Ruthanne Holbert, imaging specialist. Curran makes adjustments, arranging and rearranging his objects after viewing his composition in preview mode, until he has the scan he wants. Before a final scan is made, color alterations are made by adjusting the gamma. All other settings are left on auto. The final scan is made at a resolution of 200 percent for output to a 8" x 12" print. Nash Editions prints Curran's photomontages on Rives BFK 100 percent rag, a French handmade paper which is normally used for watercolor and printmaking.

Curran has sold a number of his scanned montages to fine arts collectors. Because Nash Editions keeps his scanned images on file, there's no need for Curran to archive an edition of prints.

Schmeltz + Warren

The Columbus, Ohio, design firm of Schmeltz + Warren was founded in 1980 by principals Catherine Schmeltz and Crit Warren. The firm's work has won numerous awards and has been featured in *Publish* and *HOW* magazines as well as several design books.

Since 1985 the computer has been an integral part of the firm's design and production process. Schmeltz + Warren's work reflects the team's aptitude for digital processes, employing plenty of imagery and typographic effects only attainable through computer manipulation and enhancement.

When the Cincinnati chapter of the American Institute of Graphic Artists (AIGA) wanted a poster to promote a special meeting, Schmeltz + Warren was asked to take part in a collaborative design effort that included four design firms from the region. Each firm designed and produced an electronically composed 9" x 18" panel that would be incorporated into a poster illustrating The Future of Visual Communication, the theme of the upcoming meeting.

For its panel, Schmeltz + Warren was asked to depict the source of inspiration by concepting "Where Do Ideas Come From?". Designer Crit Warren chose to illustrate this concept by combining images that represent raw information found in life around us. He intermixed them in a somewhat random fashion into a collage that captures the jumble of thoughts and images that serve as the

"SCAN EACH PICTURE TO THE FULL OPTICAL RESOLUTION POTENTIAL OF THE SCANNER, THEN BRING YOUR IMAGE INTO PHOTOSHOP TO CROP, SCALE AND CHANGE IMAGE RESOLUTION. NEVER RESIZE AN IMAGE MORE THAN 5 PERCENT IN A PAGE LAYOUT PROGRAM."

basis for creative concepting.

The original photography Warren chose were photos he had shot in and around the Columbus area. They were in a variety of formats that included 35mm color chromes, 35mm black-and-white negatives, and Polaroid transfers that were shot onto 35mm film and then scanned.

Using a Barneyscan CIS 3515 35mm scanner (Barneyscan now manufactures scanners under the name PixelCraft) equipped with QuickScan software, Warren scanned all of the 35mm color chromes and black-and-white negatives at a resolution of 1,200 spi. Tone curves were adjusted to add contrast to quarter tones, midtones and three-quarter tones. Polaroid transfers, which provided the collage's background imagery, were scanned on an Apple black-and-white scanner.

To assemble the collage, all images were brought into Photoshop where they were further adjusted for color balance and tonal compression. Images such as the motel sign were isolated from their backgrounds while others were cropped.

The finished collage was output at a resolution of 266 spi through Scitex Gateway, where the printer combined it with the digital files from the other contributors to comprise the final poster.

CHAPTER FIVE

Reference

Suggested Reading

IMAGING ESSENTIALS by Luanne Seymour Cohen, Russell Brown and Tanya Wendling.

THE PHOTOSHOP WOW! BOOK by Linnea Dayton and Jack Travis.

DESIGNER PHOTOSHOP by Rob Day.

THE OFFICIAL ADOBE PHOTOSHOP HANDBOOK by David Biedny, Bert Monroy and Mark Siprut.

REAL WORLD SCANNING AND HALFTONES by David Blatner and Steve Roth.

FOUR COLORS/ONE IMAGE by Matthias Nyman.

THE COLOR MAC by Marc D. Miller and Randy Zaucha.

COLOR PUBLISHING ON THE MACINTOSH by Kim and Sunny Bakur.

HALFTONE EFFECTS by Peter Bridgewater and Gerald Woods.

THE COLOR RESOURCE COMPLETE COLOR GUIDE by Miles Southworth, Thad McIlroy and Donna Southworth.

Training/Professional Organizations

IDEA (INTERNATIONAL DESIGN BY ELECTRONICS ASSOCIATION), 2200 Wilson Boulevard, Suite 102-153, Arlington, VA 22201, (800) 466-1163

A professional design organization dedicated solely to electronic design issues.

CENTER FOR CREATIVE IMAGING, 51 Mechanic Street, Camden, ME 04843, (800) 428-7400

A software training facility that offers week-long training sessions, including classes and seminars in electronic imaging, illustration, publishing, animation and multimedia.

THE COLOR CENTER, 8 Oak Park Drive, Bedford, MA 01730, (800) 229-0007

Basic and advanced training in popular desktop publishing applications and processes. Cities serviced include Boston, New York, Chicago, Los Angeles, San Francisco, Atlanta and Washington, DC.

Software
(Listed alphabetically by manufacturer)

ADOBE SYSTEMS, INC., 1585 Charleston Road, Mountain View, CA 94043, (415) 961-4400, (800) 833-6687

Adobe Photoshop—The de facto standard image-editing software. Macintosh and Windows.

Adobe Streamline—A robust stand-alone auto-tracing tool. Macintosh and Windows.

Aldus PhotoStyler—High-end image-manipulation software for Windows.

Aldus Gallery Effects, volumes 1, 2, 3—Plug-in filters and textures for creative image effects. Macintosh and Windows.

Aldus Color Central—High-end OPI print server software for automatically printing/queueing/separating large image files. Macintosh.

AGFA DIVISION, MILES INC., 90 Industrial Way, Wilmington, MA 01887, (800) 685-4271, (800) 343-1237

FotoTune—Agfa's color management system includes more than one hundred ColorTag profiles for various scanners, monitors and printers; an IT8 color reference target; and calibration software. Macintosh.

FotoLook—Extended FotoTune support for Agfa scanners.

APPLE COMPUTER, 1 Infinity Loop, Cupertino, CA 95014, (800) 776-2333

PhotoFlash—Image access, correction and management tool for Macintosh.

QuickTime—Core system image, video and sound technology. Macintosh and Windows.

QuickDraw GX—Core system graphics toolbox technology. Macintosh.

ColorSync—Core system color management technology. Macintosh.

CANTO SOFTWARE, 800 DuBoce Avenue, San Francisco, CA 94117, (800) 332-2686, (415) 431-6871

Cirrus—Scriptable image editing, color correction, color management and scanning support for many popular desktop scanners. Macintosh.

DAYSTAR DIGITAL, 5556 Atlanta Highway, Flowery Branch, GA 30542, (800) 962-2077

PhotoMatic—Photoshop plug-in that automates repetitive tasks using a macro recording technology.

ColorMatch—Color management system that includes monitor calibration, Kodak device profiles, color correction, CMYK preview, and support for Photoshop, QuarkXPress and PageMaker. Optional 8-bit/color colorimeter. Macintosh.

EASTMAN KODAK, Dept. 841, 343 State Street, Rochester, NY 14650-0811, (800) 242-2424

Kodak Shoebox—Photo CD image manager and catalog. Macintosh and Windows.

Kodak PhotoEdge—Photo CD image enhancement tool. Macintosh and Windows.

Kodak Photo CD Access—Stand-alone Photo CD image capture application. Macintosh and Windows.

ELECTRONICS FOR IMAGING, 2855 Campus Drive, San Mateo, CA 94403, (415) 286-8600

EfiColor Works—A complete color management system, including targets, profiles, profile editor, QuarkXTensions and Photoshop plug-in.

HSC SOFTWARE CORP., 6303 Carpinteria Avenue, Carpinteria, CA 93013, (805) 566-6385

Kai's Power Tools—A powerful set of unique Photoshop plug-in filters. Full of way-cool effects and fractal designs. Macintosh and Windows.

HSC Live Picture—High-end image manipulation and creation tool utilizing FITS technology for Macintosh.

KPT Bryce—"Sleepware" that turns your Macintosh into a virtual-world image creator. Macintosh.

FRACTAL DESIGN, P.O. Box 2380, Aptos, CA 95001, (408) 688-5300

Fractal Design Painter—Image manipulation tool using live media effects such as watercolor, chalk, airbrush and even van Gogh. Macintosh and Windows.

LIGHT SOURCE, 17 East Sir Francis Drake Boulevard, Suite 100, Larkspur, CA 94939, (415) 461-8000

Ofoto—Automated scanning environment for popular desktop scanners. Macintosh and Windows.

AeQ—High-end appearance equivalence color management system and color matching method. Macintosh.

MONACO SYSTEMS, INC., 100 Burtt Road, Andover, MA 01810, (508) 749-9944

MonacoColor—An intelligent, high-end, color separation/optimization plug-in for Photoshop that optimizes scans for publication-quality output. Macintosh.

PIXELCRAFT (BARNEYSCAN/COLOR IMAGING SYSTEMS), 1125 Atlantic Avenue, Alameda, CA 94501, (415) 521-3388 or 130 Doolittle Drive, #19, San Leandro, CA 94577, (800) 933-0330

ColorAccess—High-end image correction and prepress tool for Macintosh.

CIS QuickScan—Stand-alone scanning software for high-end scanners. Supports Sharp, PixelCraft, Xerox and others. Macintosh.

PRE-PRESS TECHNOLOGIES, 2443 Impala Drive, Carlsbad, CA 92008, (619) 931-2695

SpectrePlug-In Color Correction—Plug-in utility for Photoshop that allows selective color correction.

RAY DREAM INC., 1804 North Shoreline Boulevard, Mountain View, CA 94043, (415) 960-0765

JAG II—Resolution boosting and anti-aliasing utility. Macintosh.

RON SCOTT INC., 100 Jackson Boulevard, Houston, TX 77006, (713) 529-5868

HiRes QFX—High-resolution image editing with workstation performance on a PC.

SOUTHWEST SOFTWARE, 3435 Greystone Drive, Suite 104, Austin, TX 78731, (512) 345-2493

Encore—Calibration software for desktop color scanners.

Hardware

(Listed alphabetically by manufacturer)

A4TECH, 717 Brea Canyon, Suite 12, Walnut, CA 91789, (909) 468-0071

AF-2400c—Entry-level, 8½" x 14", 8-bit/color, 600 x 1,200-spi flatbed scanner. Optional transparency adapter. Macintosh and Windows.

ADVANCED NETWORK SYSTEMS, 16275 Monterey Road, Suite N, Walnut Creek, CA 95037, (408) 776-8510

Artiscan 1200c—Entry-level, 8½" x 11", 8-bit/color, 600 x 1,200-spi flatbed scanner. Optional transparency adapter. Macintosh and Windows.

AGFA DIVISION, Miles Inc., 90 Industrial Way, Wilmington, MA 01887, (800) 685-4271, (800) 343-1237

Vision 35—Midlevel, 8-bit/color, 2,750-line resolution, 35mm film scanner. Macintosh and Windows.

Agfa StudioScan II—Entry-level, 8½" x 14", one-pass, 8-bit/color, 400 x 800-spi flatbed scanner. Optional transparency adapter. Includes Adobe Photoshop LE. Macintosh and Windows.

Agfa Arcus II—Midlevel, 8½" x 14", three-pass, 10-bit/color, 600 x 1,200-spi flatbed scanner. Optional transparency adapter. Macintosh and Windows.

Agfa Horizon II—High-end, 11" x 17", three-pass, 12-bit/color, 600 x 1,200-spi flatbed scanner. Macintosh and Windows.

APPLE COMPUTER, 1 Infinity Loop, Cupertino, CA 95014, (800) 776-2333

Apple OneScanner—Entry-level, 8½" x 14", grayscale, 300 x 600-spi flatbed scanner. Includes Ofoto. Macintosh and Windows.

Apple Color OneScanner—Entry-level, 8½" x 14", 8-bit/color, 300 x 600 flatbed scanner. Includes Ofoto. Macintosh and Windows.

QuickTake 100—Lightweight portable digital color camera. Maximum resolution 640 x 480. Macintosh and Windows.

APS TECHNOLOGIES, 6131 Deramus, Kansas City, MO 64120, (816) 483-1600

SCSI Sentry—Active termination for SCSI chains eliminates SCSI electrical problems for any SCSI-equipped computer.

AVR TECHNOLOGY INC., 71 East Daggett Drive, San Jose, CA 95134, (800) 544-6243

AVR 8800/CLX—Entry-level, 8½" x 14", 8-bit/color, 400 x 800-spi flatbed scanner. Optional one hundred-sheet document feeder. Optional transparency adapter. Macintosh and Windows.

CAERE CORPORATION, 100 Cooper Court, Los Gatos, CA 95030, (800) 535-7226

OmniScan—8-bit/color, 400-spi hand-held scanner with 4" wide scanning area. Macintosh and Windows.

CANON COMPUTER SYSTEMS, INC., 2995 Redhill Avenue, Costa Mesa, CA 92626 (800) 848-4125

IX-4015—Entry-level, 8½" x 11", one-pass, 8-bit/color, 400 x 800-spi flatbed scanner. Optional automatic document feeder. Includes Ofoto. Macintosh and Windows.

DPI ELECTRONIC IMAGING, 629 Old State Route 74, Suite 1, Cincinnati, OH 45244, (800) 597-3837

Art-Getter—30-bit midlevel, 8½" x 11", three-pass, 10-bit/color, 600 x 1,200-spi flatbed scanner. OEM version of the Umax 1200S. Macintosh and Windows.

EASTMAN KODAK COMPANY, Dept. 841, 343 State Street, Rochester, NY 14650-0811, (800) 242-2424

RFS 2035 Plus—3,000-line resolution, 12-bit/color, 35mm slide scanner. Macintosh and Windows.

DCS 200—1,024-line resolution, 8-bit/color, portable digital camera based on a Nikon camera body. Macintosh and Windows.

ENVISIONS SOLUTIONS TECHNOLOGY, 822 Mahler Road, Burlingame, CA 94010, (800) 365-7226

ENVColor—8-bit/color, 400-spi hand-held scanner with 4" wide scanning area. Macintosh and Windows.

ENV24 Pro—Entry-level, 8½" x 14", 8-bit/color, 600 x 1,200-spi flatbed scanner. Optional transparency adapter. Macintosh and Windows.

EPSON AMERICA, 20770 Madrona Avenue, P.O. Box 2903, Torrance, CA 90509, (800) 289-3776, (800) 922-8911, (310) 782-0770

ES-600C—Entry-level, 8½" x 11", one-pass, 8-bit/color, 300 x 600-spi flatbed scanner. Optional

transparency adapter. Includes Adobe Photoshop LE. Macintosh and Windows.

ES-800C Pro—Entry-level, 8½" x 11", one-pass, multilamp, 8-bit/color, 400 x 800-spi flatbed scanner. Optional transparency adapter. Includes Adobe Photoshop and Kai's Power Tools. Macintosh and Windows.

ES-1200C Pro—Mid-level, 8½" x 11", one-pass, multilamp, 10-bit/color, 600 x 1,200-spi flatbed scanner. Optional transparency adapter. Includes Adobe Photoshop and Kai's Power Tools. Macintosh and Windows.

FUJITSU, 2904 Orchard Parkway, San Jose, CA 95134, (800) 626-4686

ScanPartner 10—Entry-level, 8½" x 14", one-pass, 8-bit/color, 400 x 800-spi flatbed scanner. Optional automatic document feeder. Macintosh and Windows.

HEWLETT-PACKARD COMPANY, 5301 Stevens Creek Boulevard, Santa Clara, CA 95052, (800) 722-6538

ScanJet IIcx—Entry-level, 8½" x 14", one-pass, 8-bit/color, 400 x 800-spi flatbed scanner. Optional transparency adapter and automatic document feeder. Includes Photoshop LE. Macintosh and Windows.

HOWTEK, INC., 21 Park Avenue, Hudson, NH 03051, (603) 882-5200

Scanmaster 7500 Pro—High-end, high-resolution, large format, multiplatform drum scanner.

Howtek Scanmaster D4000—High-end, high-resolution, large format, multiplatform drum scanner.

ICG NORTH AMERICA, 113 Main Street, Hackenstown, NJ 07840, (908) 813-3101

350i—High-end drum scanner with 12½" x 18½" image area and PowerPC compatible, expert-system scanning software. Macintosh.

LASERGRAPHICS, INC., 20 Ada, Irvine, CA 92718, (800) 727-2655

LFR Mark III—Midlevel, 8,000-line resolution slide scanner. Macintosh and Windows.

LA CIE, 8700 SW Creekside Place, Beaverton, OR 97008, (800) 999-0143, (503) 520-9000

Silverscanner II—Entry-level, 8½" x 11", one-pass, 8-bit/color, 400 x 800-spi flatbed scanner. Optional transparency adapter. Macintosh and Windows.

LEAF SYSTEMS, INC., a Scitex Company, 250 Turnpike Road, Southboro, MA 01772, (508) 460-8300, (800) 685-9462

Lumina—Unique midlevel, 10-bit/color, lens mounted, 3,600-line resolution scanner/camera. Macintosh and Windows.

Leafscan 35—High-end, 14-bit/color, 4,000-line resolution, 35mm film scanner. Macintosh and Windows.

Leafscan 45—High-end, 14-bit/color, 4,000-line resolution, multi-format film scanner. Macintosh and Windows.

Leaf Digital Back—High-end, 12-bit/color, 2,000 x 2,000 pixel, digital back for Hasselblad and Mamiya studio cameras. Macintosh.

LIGHT SOURCE, 17 East Sir Francis Drake Boulevard, Larkspur, CA 94939, (415) 925-4200, (415) 461-8000

Colortron—Affordable, professional-caliber, color densitometer and utilities. Macintosh.

LOGITECH, 6505 Kaiser Drive, Freemont, CA 94555, (800) 231-7717

ScanMan Color—8-bit/color, 400-spi hand-held scanner with 4" wide scanning area. Macintosh and Windows.

MICROTEK, 3715 Doolittle Drive, Redondo Beach, CA 90278, (800) 654-4160, (310) 352-3300

ScanMaker Scooter—8-bit/color, 400 spi, motorized/hand-held scanner with 4" wide scanning area. Macintosh and Windows.

ScanMaker III—Midlevel, 8½" x 14", three-pass, 12-bit/color, 600 x 1,200-spi flatbed scanner. Optional transparency adapter. Includes Adobe Photoshop. Macintosh and Windows.

ScanMaker IIHR—Entry-level, 8½" x 14", three-pass, 8-bit/color, 600 x 1,200-spi flatbed scanner. Optional transparency adapter. Includes Adobe Photoshop. Macintosh and Windows.

ScanMaker IIXE—Entry-level, 8½" x 14", three-pass, 8-bit/color, 300 x 600-spi flatbed scanner. Optional transparency adapter. Includes Adobe Photoshop. Macintosh and Windows.

ScanMaker IISP—Entry-level, 8½" x 14", single-pass, 8-bit/color, 300 x 600-spi flatbed scanner. Includes Adobe Photoshop LE. Macintosh and Windows.

ScanMaker 35t—Midlevel, 8-bit/color, 3,656-line resolution, 35mm film scanner. Includes Adobe Photoshop LE. Macintosh and Windows.

ScanMaker 45t—Midlevel, 12-bit/color, 2,000-line resolution, multi-format film scanner. Includes Adobe

Photoshop. Macintosh and Windows.

MIRROR TECHNOLOGIES, 5198 West 76th Street, Edine, MN 55439, (800) 654-5294, (612) 832-5406

Mirror 800 Plus—Entry-level, 8½" x 14", three-pass, 8-bit/color, 400 x 800-spi flatbed scanner. Optional transparency adapter. Includes Adobe Photoshop. Macintosh and Windows.

NIKON, 1300 Walt Whitman Road, Melville, NY 11747, (800) 526-4566, (516) 547-4200

Nikon LS-3510AF—Midlevel, 12-bit/color, autofocus, 3,600-line resolution slide scanner. Macintosh and Windows.

Nikon Coolscan—Entry-level, 8-bit/color, low-cost, 1,850-line resolution, half-height slide scanner. Macintosh and Windows.

OPTRONICS, an Intergraph Division, 7 Stuart Road, Chelmsford, MA 01824, (508) 256-4511

Optronics ColorGetter—High-end, high-resolution drum scanner.

PANASONIC, 1 Panasonic Way, Secaucus, NJ 07094, (708) 468-4308, (800) 742-8086

FX-RS308Ci—Entry-level, 600 x 600 spi, 8½" x 14", single-pass, 8-bit/color flatbed scanner. Includes Aldus PhotoStyler SE for Windows.

PIXELCRAFT, INC., a Xerox Company, 130 Doolittle Drive #19, San Leandro, CA 94577, (510) 562-2480, (800) 933-0330

PixelCraft Pro Imager 8000—High-end, 11" x 17", one-pass, 14-bit/color flatbed scanner. Macintosh and Windows.

PixelCraft Pro Imager 7650—High-end, 11" x 17", one-pass, 12-bit/color flatbed scanner. Macintosh and Windows.

PixelCraft Pro Imager 4520RS—High-end, 12-bit/color, 2,000-line resolution, multi-format transparency scanner. Macintosh and Windows.

POLAROID, 784 Memorial Drive, Cambridge, MA 02139, (617) 386-2000, (800) 816-2611

Sprint Scan 35—Midlevel, 10-bit/color, 2,750-line resolution, 35mm film scanner. Macintosh and Windows.

RELISYS, 919 Hanson Court, Milpitas, CA 95035, (800) 945-0900

Reli 9624—8.3" x 11.7", one-pass, 8-bit/color, cold-scan, 2,400 x 600-spi flatbed scanner with built-in transparency adapter. Optional automatic docu-ment feeder. Macintosh and Windows.

Reli 4816—8½" x 14", one-pass, 8-bit/color, cold-scan, 1,600 x 400-spi flatbed scanner with built-in transparency adapter. Optional automatic document feeder. Macintosh and Windows.

Reli 2412—8½" x 14", one-pass, 8-bit/color, cold-scan, 1,200 x 300-spi flatbed scanner with built-in transparency adapter. Optional automatic document feeder. Macintosh and Windows.

RICOH IMAGING PERIPHERAL PRODUCTS, San Jose, CA, (800) 955-3453

FS2—8½" x 11", one-pass, 10-bit/color, 600 x 1,200-spi flatbed scanner. Optional transparency adapter. Macintosh and Windows.

SCANVIEW, A/S Meterbuen 6, Skovlunde, Denmark, DK-2740, +45 44 53 6100

ScanMate Plus—8½" x 11", one-pass, 8-bit/color flatbed scanner. Optional transparency adapter. Macintosh and Windows.

SCREEN USA, 5110 Tollview Drive, Rolling Meadows, IL 60008, (708) 870-7400

DT-S 1030AI—Large-format, high-resolution laser drum scanner. Macintosh and Windows.

DT-S 1015AI—Small-format, high-resolution laser drum scanner. Macintosh and Windows.

SHARP ELECTRONIC CORP., 1300 Naperville Drive, Romeoville, IL 60441, (800) 237-4277, #3

JX-610—High-end, 11" x 17", one-pass, three-lamp, 12-bit/color, 600 x 600-spi flatbed scanner. Optional transparency adapter. Macintosh and Windows.

JX-325—Entry-level, 8½" x 11", one-pass, 8-bit/color, 300 x 600-spi flatbed scanner. Optional transparency adapter. Includes Adobe Photoshop.

SPARK INTERNATIONAL INC., P.O. Box 314, Glenview, IL 60025, (708) 998-6640

Spectrum Scan III—8½" x 11", one-pass, 8-bit/color, 600 x 1,200-spi flatbed scanner with integrated transparency adapter. Optional automatic document feeder. Macintosh and Windows.

SUMMAGRAPHICS, 8500 Cameron Road, Austin, TX 78759, (800) 337-8662

LDS 8000W—40" wide, 400 spi, grayscale, SCSI supported, sheet-sized digitizer.

TAMARACK, 1544 Centre Pointe Drive, Milpitas, CA 95035, (800) 643-0666

Artiscan 12000c—Entry-level, 8½" x 11", one-pass, 8-bit/color, 600 x 1,200-spi flatbed scanner. Optional transparency adapter. Macintosh and Windows.

UMAX TECHNOLOGIES, INC., 3353 Gateway Boulevard, Fremont, CA 94538, (510) 651-8883, (800) 769-7848

BizCard Reader—Small, inexpensive, parallel-port-driven, business card scanner for Windows.

PowerLook—Midlevel, 8½" x 14", single-pass, 10-bit/color, 600 x 1,200-spi flatbed scanner with built-in transparency adapter. Macintosh and Windows.

UC1260—Entry-level, 8½" x 14", three-pass, 8-bit/color, 600 x 1,200-spi flatbed scanner. Optional transparency adapter. Macintosh and Windows.

UC840—Entry-level, 8½" x 14", three-pass, 8-bit/color, 400 x 800-spi flatbed scanner. Optional transparency adapter. Macintosh and Windows.

UC630—Entry-level, 8½" x 14", three-pass, 8-bit/color, 300 x 600-spi flatbed scanner. Optional transparency adapter. Macintosh and Windows.

VISIONSHAPE, 1434 West Taft, Orange, CA 92665, (714) 282-2668

VS-1251—Dual-sided, 11" x 17", single-pass, black and white, 300 x 300-spi flatbed scanner, with built-in automatic document feeder. Macintosh and Windows.

WACOM, 501 SE Columbia Shores Boulevard, Suite 300, Vancouver, WA 98661, (206) 750-8882

Artz digitizing tablet—Available in 6" x 8" for the Macintosh ADB (mouse/keyboard) port.

Wacom digitizing tablets—Available in 6" x 9", 12" x 12", and 18" x 18" sizes. Serial port version. Macintosh and Windows.

Pick the Right SPI

Sample Rate

Most scanning experts advise that good quality halftones require a scan from 1 to 2 pixels per printed halftone dot. However, I have found that a 1-to-1 pixel per halftone dot ratio is adequate for many purposes. I use that sample rate for all my cover designs for the Boston Computer Society IBM User Group Newsletter, *PC Report*. The obvious advantage of a 1-to-1 sample rate is smaller file size. For instance, each of my *PC Report* covers is just 6.3MB. A scan of 2 pixels per halftone dot would result in an image nearly four times as big!

Although purists insist that optimal imagesetting requires a 2-to-1 sample rate, newer thinking suggests that a 1.5-to-1 sampling rate is more than a good compromise.

Optimal spi settings at 1.0 sampling ratio

	HALFTONE SCREEN FREQUENCY				
SPI	**65**	**85**	**100**	**133**	**150**
75	115%	88%	75%	56%	50%
90	138%	106%	90%	68%	60%
100	154%	118%	100%	75%	67%
120	185%	141%	120%	90%	80%
150	231%	176%	150%	113%	100%
180	277%	212%	180%	135%	120%
200	308%	235%	200%	150%	133%
210	323%	247%	210%	158%	140%
240	369%	282%	240%	180%	160%
270	415%	318%	270%	203%	180%
300	462%	353%	300%	226%	200%
360	554%	424%	360%	271%	240%
400	615%	471%	400%	301%	267%
480	738%	565%	480%	361%	320%
600	923%	706%	600%	451%	400%
800	1231%	941%	800%	602%	533%
1200	1846%	1412%	1200%	902%	800%

Calculating the optimal scan for a given output is relatively easy. Just plug in the enlargement or reduction percentage you want for the appropriate halftone screen.

My feeling is that images on low-grade, coarse or uncoated papers and background images can get away with 1-to-1 sampling while images on high-quality coated stock or images that may need to be resized in the future are better sampled at 1.5-to-1 or 2-to-1.

For very small images (less than 3 inches), I suggest scanning at a 2-to-1 ratio. The halftone looks better, the size of the file isn't significantly bigger, and you can enlarge and/or crop the image a bit if you decide to later.

Optimal spi settings at 1.5 sampling ratio

HALFTONE SCREEN FREQUENCY

SPI	65	85	100	133	150
75	77%	59%	50%	38%	33%
90	92%	71%	60%	45%	40%
100	103%	78%	67%	50%	44%
120	123%	94%	80%	60%	53%
150	154%	118%	100%	75%	67%
180	185%	141%	120%	90%	80%
200	205%	157%	133%	100%	89%
210	215%	165%	140%	105%	93%
240	246%	188%	160%	120%	107%
270	277%	212%	180%	135%	120%
300	308%	235%	200%	150%	133%
360	369%	282%	240%	180%	160%
400	410%	314%	267%	201%	178%
480	492%	376%	320%	241%	213%
600	615%	471%	400%	301%	267%
800	821%	627%	533%	401%	356%
1200	1231%	941%	800%	602%	533%

Optimal spi settings at 2.0 sampling ratio

SPI	HALFTONE SCREEN FREQUENCY				
	65	85	100	133	150
75	58%	44%	38%	28%	25%
90	69%	53%	45%	34%	30%
100	77%	59%	50%	38%	33%
120	92%	71%	60%	45%	40%
150	115%	88%	75%	56%	50%
180	138%	106%	90%	68%	60%
200	154%	118%	100%	75%	67%
210	162%	124%	105%	79%	70%
240	185%	141%	120%	90%	80%
270	208%	159%	135%	102%	90%
300	231%	176%	150%	113%	100%
360	277%	212%	180%	135%	120%
400	308%	235%	200%	150%	133%
480	369%	282%	240%	180%	160%
600	462%	353%	300%	226%	200%
800	615%	471%	400%	301%	267%
1200	923%	706%	600%	451%	400%

Scanning Formula

Here's a formula that can help you calculate the appropriate number of samples per inch (spi) when scanning:

Halftone Screen (lpi) x Sampling Rate (spi) = Output Resolution (ppi)

Magnification/100 x Output Resolution (ppi) = Target Scanning Resolution (spi)

Here's how it works if you want to scan an image at a sample rate of 1.5 and output it to a 150-line screen for final reproduction at 80 percent of its original size: Output resolution is 150 x 1.5 = 225 ppi. Since the reduction is 80 percent, the target scanning resolution is 80/100 x 225 = 180 spi.

I created the tables on this and the previous two pages with a spreadsheet program using the formula above for each cell. You may be able to create other application-specific tables for your own use or even program a hand calculator to do the same.

Note: An important downside to 2-to-1 scanning is that film output takes longer and in many cases you are charged extra for the RIP time. That 1.5-to-1 ratio looks better all the time, doesn't it? On the upside, you can change your mind and enlarge the picture much more if you have 2-to-1 sampling. As I said, for important images 2-to-1 is a good bet.

Scan Calculator

For those of you who don't like tables and calculations, there is a nifty shareware HyperCard stack available for downloading from CompuServe and other online services called Scan Calculator. Two screens from the program are shown on this page.

To order your copy of Scan Calculator send $27.00 in check or money order to:

Robert W. Emenecker, Jr.
Standing Rock Solutions
503 Deer Run East
Norriton, PA 19403

SCAN CALCULATOR

Scan Calculator

Original Image Information

Dimensions...
Width: 4.0 inch
Height: 6.0 inch

Type of Original...
Color Photograph

Image Detail...
Balanced

Image Quality...
Normal

• Final Image Information •

Dimensions...
Width: 6.0 inch
Height: 9.0 inch

Final Scale...
150 %

Type of Final...
Color Separation

Line Screen...
150

Enter Data | Quit | Print Report | View Report

In this dialog box, you enter the beginning size, ending size, and the kind of image you are working with.

Scan Calculator

•• Pre-Scan Information ••
Image Name: **test Image**
Original Width: **4.0 inches**
Original Height: **6.0 inches**
Final Scale: **150%**
Scanning Media: **Color Photograph**
Final Product: **Color Separation**
Detail: **Balanced**
Evaluation: **Normal**
Halftone LPI: **150 line screen**

•••• Scanner Settings ••••
Image Type: **Color**
Resolution: **400 DPI**
Gamma: **1.8**
Edge Emphasis: **None**
Scan Speed: **Slow**

• Post Scan Adjustments •
Mode
Convert to: **CMYK**
Levels
Midtone Range: **1.10–1.25**
Shadow Dot: **8**
Highlight Dot: **247**
Image Size
Image Width: **6.0 inches**
Image Height: **9.0 inches**
Resolution: **225 DPI**
Unsharp Mask
Percentage: **100%**
Pixel Radius: **1.0**
Threshold: **0**

Enter Data | Quit | Print Report | View Report

After entering the necessary specs, this dialog box displays the recommended settings.

Legal and Ethical Issues

Who Owns This Image?

Scanning an image that somebody else has created is, by legal definition, reproducing an image—an act that requires the granting of reproduction rights by the image's owner. Once the image is scanned, digitally altering it is creating, by legal definition, a derivative work. Creating a derivative work requires permission from the owner of the original who then grants adaption rights.

A host of issues surrounds which images can and cannot legally be used for scanning purposes. Understanding these issues can prevent you from being sued. The legal areas that may cumulatively or separately affect your right to scan a given image are:

- Copyright
- Moral rights
- Trademark
- Trade secret

Copyright

The most widely used, and misunderstood, law regarding the use of images is the copyright. Under current United States law, an image doesn't have to have a copyright notice (the © symbol) to be protected by copyright.

The idea of a copyright is to give an artist exclusive rights to profit from a work that he or she created for a set period of time. After the term has expired, the copyrighted work automatically falls into the public domain. Thus, the public has a right to use a work once the original artist has been given fair chance to make money from it.

Images created prior to 1978 become public domain twenty-eight years after their creation, unless their copyright has been renewed, which entitles them to an additional forty-seven years of protection. Images created on or after January 1, 1978, are covered under copyright protection until seventy-five years after their creation. Unpublished works are protected for fifty years after a copyright holder's death.

Using an image, including scanning it, without a license from the copyright owner is an infringement of the copyright. Infringers may be sued by the copyright owner or heirs for damages, legal fees and more.

What's Copyright Free?

- Clip Art Images—You can scan any clip art images that are clearly marked as "copyright free" images.
- Old Images—Basically anything seventy-five years old or more (i.e., 28 + 47) is safe to scan, although other protection may apply. Images twenty-eight years old or older may also be useable, but you should first determine if a copyright extension was applied for before you scan such an image.
- Public Domain—Any image that has been deliberately given to the public is OK to use. The problem is determining which images qualify. Note that most NASA images are available to the public, with proper credit, since your tax dollars paid for them. But the problem is that if you scan a NASA image from a magazine or book you may be violating that publisher's copyright since they may have enhanced the original image in ways that you are unaware of.

Moral Rights

A new twist to the copyright law is the passage of the Visual Artists Rights Act of 1990. In effect, this law gives an artist the right to claim authorship of a work, the right to prevent associating an artist's name with a work that artist didn't create, and the right to prevent any intentional distortion or modification of a work. Using such protection, artists may prevent you from changing, in any way, a scan of their work, even if that work is in the public domain. Thus, if you photograph an artist's painting, scan it, and modify it in an image manipulation program, then you may be violating the artist's moral rights. Again, if it isn't yours, get permission first.

Trademarks

You should also be aware of another legal protection device—the trademark. Corporate logos are usually protected under trademark law and shouldn't be scanned or used without permission. Watch out for familiar graphics or characters—Snoopy, Dilbert, Mickey Mouse and Opus are all trademarked, and using their images, even innocently, can be hazardous to your pocketbook. Some trademark holders are particularly litigious.

Trade Secrets

Trade secrets protection offers perpetual protection as long as the information being copied remains a secret. Copying plans, drawings, diagrams, lists, documents and even certain photographs that belong to a corporation may expose you to a lawsuit—especially if you move to another corporation and take those copies with you. Your former employer can enjoin you from going to work for a competitor, especially if you signed a nondisclosure agreement.

Ethics

Perhaps most important of all are ethical considerations. To be fair, you should always attempt to get permission to use someone else's image. You might be surprised—you may get to use it for free if your cause is good and the originator feels sympathetic. On the other hand, if you are making beaucoup bucks on a project, then it is reasonable to expect to share some of the proceeds with others.

For many people, taking pictures, producing art and creating illustrations is their only means of earning a living. Additionally, an entire industry of support people—from photo labs to artists' reps to publishers—depend on the work that photographers, artists and illustrators create. This community is damaged each time someone makes a copy of something that belongs to someone else. It is up to you to respect the work of others when scanning, as much as you expect others to respect your own.

How to Protect Your Own Images From Plagiarism

Your work is your copyrighted material and it doesn't necessarily have to be registered with the Copyright Office to be protected under copyright laws. Significantly altering or modifying a scanned public domain image qualifies as a new, derivative work and is automatically protected. All pictorial, graphic and three-dimensional artwork can be copyrighted. You can discourage others from plagiarizing your work or otherwise profiting from it by including a copyright (such as © your name, year) on your original.

To register your work, contact the Federal Copyright Office, Library of Congress, LM 455, Washington, DC 20559, phone (202) 707-3000. You can also request a number of publications prepared by the Copyright Office. Circular 1 is Copyright Basics, Circular 2 lists all other publications. Circulars 22 and 23 cover searching Copyright Office records to determine the copyright status and/or ownership of a work.

For More Information

AMERICAN SOCIETY OF MEDIA PHOTOGRAPHERS, 14 Washington Road, Suite 502, Princeton Junction, NJ 08550, (609) 799-8330

The society offers several pertinent publications: *Membership Directory* ($18.00), *Copyright Guide for Photographers* ($5.00), and *Stock Photography Handbook (*$29.95), which includes a list of stock picture agencies.

GRAPHIC ARTISTS GUILD, 11 West 20th Street, New York, NY 10011-3704, (212) 463-7730

The Graphic Artists Guild offers a number of publications, including *Ethical Guide to Graphic Design and Illustration Services* ($29.95). The Guild is a strong advocate for the rights of visual artists.

PICTURE RESEARCH: A PRACTICAL GUIDE ($37.95), by John Schultz and Barbara Schultz, published by Van Nostrand Reinhold, 7625 Empire Drive, Florence, KY 41042, (800) 842-3636

Covering the background and techniques of acquiring reproduction rights and researching ownership for photographs and other pictures, this highly recommended book includes chapters on copyright law as well as electronic publishing.

THE ART LAW PRIMER: A MANUAL FOR VISUAL ARTISTS ($9.95), by Linda F. Pinkerton and John T. Guardalabene, published by Lyons & Burford, 31 West 21st Street, New York, NY 10010, (212) 620-9580

An introduction to all sorts of legal areas that photographers and other visual artists are likely to encounter, including an excellent chapter on copyright.

LEGAL GUIDE FOR THE VISUAL ARTIST ($19.95), by Tad Crawford, published by Allworth Press, distributed by F&W Publications, 1507 Dana Avenue, Cincinnati, OH 45207, (513) 531-2690

This is an introduction to all sorts of legal areas that photographers, illustrators and other visual artists are likely to encounter. Includes examples of legal contracts and provides an excellent overview on copyright.

MULTIMEDIA: LAW & PRACTICE ($125.80) by Michael D. Scott, published by Prentice Hall Law & Business, 270 Sylvan Avenue, Englewood Cliffs, NJ 07632, (800) 223-0231 (1993)

An excellent, easy-to-read survey of the legal issues involved in using material for multimedia in regard to copyrights, moral rights, trademarks and patent law.

Glossary

A/D CONVERTER—Analog-to-digital converter. An electronic device that converts an analog signal, such as that generated by a CCD, into digital information.

ADDITIVE PRIMARIES—Another name for red, green and blue. Called additive because when all three are combined they create pure white.

ALIASING—*See* **JAGGIES**.

ANALOG—Continuously variable signals or data, as opposed to digital.

BIT—Binary digit. The basic unit of information that all computers use to manipulate data. The value of a bit (0 or 1) represents a two-way choice, such as yes/no, on/off or black/white.

BIT DEPTH—The amount of tone data per sample expressed in number of bits. Typical bit depths are 1 (for line art), 8 (for grayscale), and 24 (for color images).

BITMAP—Originally a term used to describe a memory model where each bit in screen memory was "mapped" to a corresponding screen pixel, hence the term *bitmapped*. Today it is used universally to describe all manner of pixel-oriented displays, from 1-bit (true bitmapped) to grayscale (8 bits per pixel) to full color (16 or 24 bits per pixel).

BLACK POINT—*See* **SHADOW POINT**.

BRIGHTNESS—The intensity of light reflected from a print, transmitted by a transparency, or emitted by a pixel.

BYTE—A computer term equal to 256 levels of information (2^8). Also, the number of bits used to represent a character. 1 byte equals 8 bits. A standard unit of measure for file size. *See also* **KILOBYTE**, **MEGABYTE**, **GIGABYTE** and **TERABYTE**.

CCD—Charge-coupled device. A light-sensitive electronic device that emits an electrical signal proportional to the amount of light striking it. Used in scanners and video cameras.

CIE—Commission Internationale de l'Eclairage. An international standards committee that defined the de facto standard color model used in all color management systems.

CD-ROM—Compact disc read-only memory. A CD-ROM drive uses the CD (compact disc) format as a computer storage medium. One CD can store approximately 640 megabytes of data and other mixed media on a disc about the size of a traditional 5¼" floppy disk.

CHANNEL—Analogous to a plate in the printing process, a channel is the foundation of a computer image. Some image types have only one channel, while others have several, with up to sixteen channels.

CMS—Color management system. A comprehensive hardware/software solution for maintaining color fidelity of an image from scanner to monitor to printer.

CMYK—Cyan, magenta, yellow, black. The subtractive primary colors plus black, also known as process colors, used in color printing. *See also* **SUBTRACTIVE PRIMARIES**.

COLOR CAST—The effect of one color dominating the overall look of an image. Often caused by improper exposure, wrong film type, or unusual lighting conditions when shooting the original image. In scanning, also caused by the sometimes unpredictable interaction between an image and a scanner.

COLOR SEPARATION—An image that has been converted or "separated" from RGB into the four process colors. *See also* **CMYK**.

COMPRESSION—Algorithms used to create smaller file sizes of stored images. There are two kinds of compression: **LOSSLESS** and **LOSSY**.

CONTRAST—The difference in brightness between the lightest and darkest tones in an image. Also, a steep region in a tone curve.

CROP—To permanently discard unwanted information in the perimeter area of an image.

DCS—Desktop color separation. A five-file EPS file format consisting of four high-resolution color separations and a fifth position-only file for placement within documents.

DECOMPRESSION—The opposite of compression. Decompressed images are as big as and have the same resolution as the original image before compression.

DEFAULT—A setting in a computer program that takes effect if no changes are made.

DENSITY—The measure of light blocking (in the case of transparencies) or absorption (in the case of prints), expressed logarithmically. Typical slides have a density of 3.0 while typical prints have a density of 2.0.

DESCREENING—The technique of eliminating moiré patterns when scanning.

DIGITAL—Discrete data made up of steps or levels, as opposed to analog.

DITHERING—A technique of using patterns of dots or pixels to create the effect of an intermediate tonal value.

DMAX—The maximum density in an image. *See also* **SHADOW POINT**.

DMIN—The minimum density in an image. *See also* **WHITE POINT**.

DOT GAIN—The effect of ink spread and absorption into paper during printing resulting in darker tones, especially midtones.

DPI—Dots per inch. A measure of the output resolution produced by laser printers or imagesetters. *See also* **LPI**.

DRIVER—A small software module that contains specific information needed by an application to control or "drive" a peripheral such as a monitor, scanner or printer.

DRUM SCANNER—A high-end scanning device, utilizing PMT technology, used to digitize prints, transparencies and artwork.

EPS—Encapsulated PostScript. A subset of the PostScript page description language that allows any single-page artwork, be it line art or image data, to be saved and placed into any other EPS-compatible document. *See also* **DCS** and **POSTSCRIPT**.

EPS 5—Another term for DCS.

EXPOSURE—Defines the overall brightness of an image resulting from a combination of time and intensity of light allowed to the film.

FILE—A named collection of binary information stored as an apparent unit on a secondary storage medium such as a computer disk drive.

FILM RECORDER—A device that renders digital data onto analog film. Typical film sizes are 35mm and 4" x 5".

FLATBED SCANNER—A popular type of desktop scanner so called because of its glass platen, or "bed," upon which originals are placed to be scanned.

FPO—For position only. Typically a low-resolution image positioned in a document only to be replaced later with a higher resolution version of the same image.

FRAME GRABBER—A device that captures and digitizes a single frame of a video sequence. Typical resolution is 640 x 480 samples.

GAMMA CORRECTION—The measure of contrast that results in lightening or darkening the midtone regions of an image. Also, the amount by which midtones need to be adjusted on a monitor.

GIGABYTE—Equivalent to exactly 1,073,741,824 bytes of information (2^{30}).

GRAYSCALE—A continuous tone image made up of a number of shades of gray. *See also* **MONOCHROME**.

HALFTONE—A technique of converting a continuous-tone (grayscale) image into variable-sized spots representing the individual tones of the image.

HALO—A consequence of using too high a setting of radius in unsharp masking. The effect is one of a light region surrounding the perimeter of a darker region.

HARD DISK—A secondary storage medium for computer files. A place to store scanned images.

HIGH KEY—An image that is primarily composed of light tones.

HIGHLIGHT—The lightest desirable tone in an image. The tonal value in an image above which all tones are rendered pure white. *See also* **DMIN** and **WHITE POINT**.

HISTOGRAM—A graphic representation of the number of samples corresponding to each tone in an image. *See also* **TONE CURVES**.

HUE—The main differentiating attribute of a color. The wavelength of light that represents a color.

ICON—In a graphical user interface, an on-screen symbol that represents a program file or computer function.

IMAGESETTER—A high-end device for taking rasterized data (*see* **RIP**) and exposing film used for printing processes.

INTERPOLATION—The technique of estimating the tonal value that lies between two known tone samples. Used for enlarging an existing image. Also used when

capturing an image during the scanning process to achieve higher than optical resolution.

INVERTING—Creating a negative of an image.

IT8—An industry standard color reference target used to calibrate scanners and printers. Many color management systems use IT8 targets.

JAGGIES—The pixelated or stair-step appearance of low-resolution computer-generated images.

JPEG—Joint Photographic Experts Group. An industry standard lossy form of compression for image data. JPEG offers one of the best compression schemes available.

KILOBYTE—Equivalent to exactly 1,024 bytes of information (2^{10}).

LASER PRINTER—A printing device using electrostatic toner to create an image derived from page description information.

LINE ART—Images comprised of only pure black-and-white data. Also a mode of capturing such images.

LOSSY—A technique of compressing an image by eliminating redundant or unnecessary information.

LOW KEY—An image that is primarily composed of dark tones.

LPI—lines per inch. A measure of the frequency of a half-tone screen used in printing. The archaic, and now misleading, term **line** harkens back to the diffraction line etchings used to create analog halftones.

LZW—Lempel-Ziv-Welch. A popular, lossless image compression algorithm.

MATRIX—A grid of horizontal and vertical cells. For example, video cameras use a matrix of CCDs.

MEGABYTE—Equivalent to exactly 1,048,576 bytes of information (2^{20}).

MIDTONE—The range of tones in an image located approximately halfway between highlights and shadows.

MODEM—MOdulator/DEModulator. An electronic device used to convert a computer's digital signal to an analog one and vice versa. The result is a signal that can be transmitted over telephone lines.

MOIRÉ—An undesirable interference pattern in color printing often resulting from misaligned or improper screen angles. Also created when previously halftoned images are scanned.

MONOCHROME—An image comprised of various shades of one hue. *See also* **GRAYSCALE**.

MONITOR—The device that produces an on-screen display. Synonymous with video display unit. There are three types of monitors: black and white, grayscale and color.

NEWTON RINGS—A pattern of concentric, multicolored rings occasionally introduced in a scanned image by contact of transparency film with the glass platen in a scanner.

NOISE—Extraneous or random samples introduced into a scanned image via the electronic components of a scanner.

OCR—Optical character recognition. Software that uses pattern recognition to distinguish character shapes in a bitmapped image. Typically used with scanners.

OFFSET LITHOGRAPHY—A commonly used printing process utilizing an intermediate blanket cylinder to transfer or "offset" an image from the plate to the paper.

OPTICAL RESOLUTION—The true number of discrete samples per inch that a scanner can distinguish in an image.

OVERSAMPLING—Scanning an image at higher than 8 bits per channel. Used for high-end image manipulation—greater bit depths allow for greater image fidelity. Available from mid- to high-level scanning equipment.

OVERSCANNING—Scanning an image at a higher resolution than is necessary. Used for archiving images for later use.

PICT—A Macintosh-based format for storage and exchange of graphic documents, containing bitmapped and/or object-based images.

PIXEL—Picture element. One of the individual elements that comprise a video monitor's image area. Typical monitor pixel resolutions are 640 x 480, 800 x 600, 1,024 x 768.

PLATEN—The glass scanning region on a flatbed scanner.

PMT—Photo multiplier tube. The kind of technology used in drum scanners.

POSTSCRIPT—A robust, general purpose page description language that has become the de facto standard in the prepress industry. Used in most all imagesetters and many laser printers.

PPI—Pixels per inch. The frequency of the number of samples used to display an image on a computer monitor.

PRESCAN—A quick, low-resolution preview scan of an image to be scanned.

PRIMARY COLOR—A base color used to create other colors. Examples are red, magenta, green, yellow, blue and cyan. Also loosely used to describe any highly saturated color.

PROFILE—The compiled color characteristics of a known device, such as a monitor or scanner, as used with a color management system.

PROCESS COLOR—The CMY primary colors (plus black) used in printing to produce the widest spectrum of printable colors. *See also* **COLOR SEPARATION**.

QUARTER TONES—Tones in an image that lie between midtones and highlights. Three-quarter tones are tones between midtones and shadows.

RAM—Random-access memory. The memory a computer needs to store the information it is processing at any given moment. Because RAM is short-term memory, it is lost when the power is shut off. The larger the amount of RAM, the larger the size of files that can be processed and the greater the speed with which they can be processed.

RASTER—A bitmapped representation of data. *See also* **RIP**.

RESAMPLE—To change the resolution (and the resulting file size) of an image. Resampling to a higher resolution introduces more data through interpolation.

RESOLUTION—The output measurement of an image, expressed in dots per inch (dpi), pixels per inch (ppi), or lines per inch (lpi)

RGB—Red, green, blue. The additive primary colors used in computer monitors and image recorders.

RIP—Raster image processor. The software/hardware device that interprets output data (such as page description information) to create a bitmapped image comprised of output dots and delivers that image to a print engine.

SAMPLE—The smallest, discrete amount of data captured by a scanner. Expressed in bit-depths of 1, 8 or 24 bits.

SATURATION—The amount of gray in a color. Less gray results in more saturation.

SCREEN FREQUENCY—*See* **HALFTONE, LPI**

SCSI—Small computer system interface. A standard that allows communication between computers and peripheral devices.

SEPARATIONS—*See* **COLOR SEPARATION**.

SHADOW POINT—The samples in an image that will print the darkest tone possible of the intended output device. Tonal values below this will print pure black. *See also* **DMAX**.

SHARPENING—A technique of accentuating the contrast between all areas of tonal difference within an image.

SPECTRAL HIGHLIGHT—Pure white with no tone. Spectral highlights within an image should not be used for Set White Point.

SUBTRACTIVE PRIMARIES—Another term for cyan, magenta and yellow. Called subtractive because when all three are combined they absorb all light (theoretically) and create black. *See also* **CMYK**.

TERABYTE—Equivalent to exactly 1,099,511,627,776 bytes of information (2^{40}).

THRESHOLD—The tonal value, used when scanning line art or converting grayscale images to bitmapped, above which is rendered white and below which is rendered black. Typically expressed in percentage of gray.

TIFF—Tag image file format. A popular file format used for storing images. TIFF formats support a wide range of color models and bit depths.

TONE CURVES—A linear graphic representation of the mapping of input tones to output tones. *See also* **HISTOGRAM**.

UNSHARP MASKING—Also known as USM. A technique of accentuating the contrast at border areas of significant tonal difference within an image. With proper controls, USM will only sharpen areas of important detail. *See also* **SHARPENING**.

WHITE POINT—The samples in an image that will print the lightest tone possible of the intended output device. Tonal values above this will print pure white. Not to be confused with spectral highlight. *See also* **DMIN**.

Permissions

Page 2. Diagram courtesy of Agfa Division, Miles Inc. Used by permission.

Page 97. Copyright © 1994 Rob Day. Illustrations published by Creative Education. Art Director: Rita Marshall. Used by permission.

Page 99. Copyright © ArtScans. Photographer: Graham Nash. Used by permission.

Page 101. Copyright © 1994 Bob and Lois Schlowsky, Schlowsky Computer Imagery, Weston, Massachusetts. Used by permission.

Page 103. Courtesy of Jonathan Reff. Copyright © 1994 Jonathan Reff. Used by permission.

Page 105. Copyright © 1994 Photonics. Photographer: Erik Von Fischer. Computer Illustration: Augie Zawatsky, Alan Brown and Matt Strippelhoff. Art Director: Al Hidalgo, Huffy, Inc. Used by permission.

Page 107. Copyright © Ron Meckler, Re: Design, New York City, New York. Used by permission.

Page 109. Copyright © 1994 Darryl J. Curran. Used by permission.

Page 111. Copyright © 1992 Schmeltz + Warren. Photographer: Crit Warren. Designer: Crit Warren.

Index

More Great Books for Great Designs!